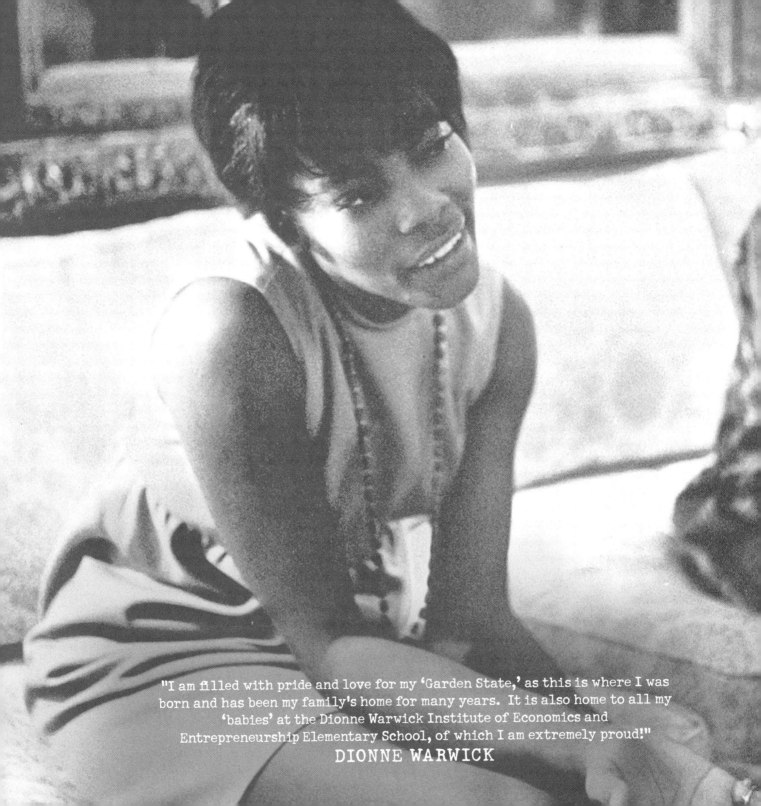

"I am filled with pride and love for my 'Garden State,' as this is where I was born and has been my family's home for many years. It is also home to all my 'babies' at the Dionne Warwick Institute of Economics and Entrepreneurship Elementary School, of which I am extremely proud!"

DIONNE WARWICK

JERSEY GIRLS
THE FIERCE AND THE FABULOUS

BY MARIE MOSS & BARRI LEINER GRANT

DESIGNED BY NANCY KRUGER COHEN

Running Press
PHILADELPHIA • LONDON

Printed in China

9 8 7 6 5 4 3 2 1
Digit on the right indicates the number of this printing

Library of Congress Control Number: 2010938392
ISBN 978-0-7624-4131-0

Edited by Cindy De La Hoz
Designed by Nancy Kruger Cohen
Typography: Firmin Didot, Bauer Bodoni, Schmutz

Running Press Book Publishers
2300 Chestnut Street
Philadelphia, PA 19103-4371

Visit us on the web!
www.runningpress.com

for marie, ellen, & danna,
and jersey girls everywhere

JERSEY GIRL

A CAWFEE TABLE BOOK

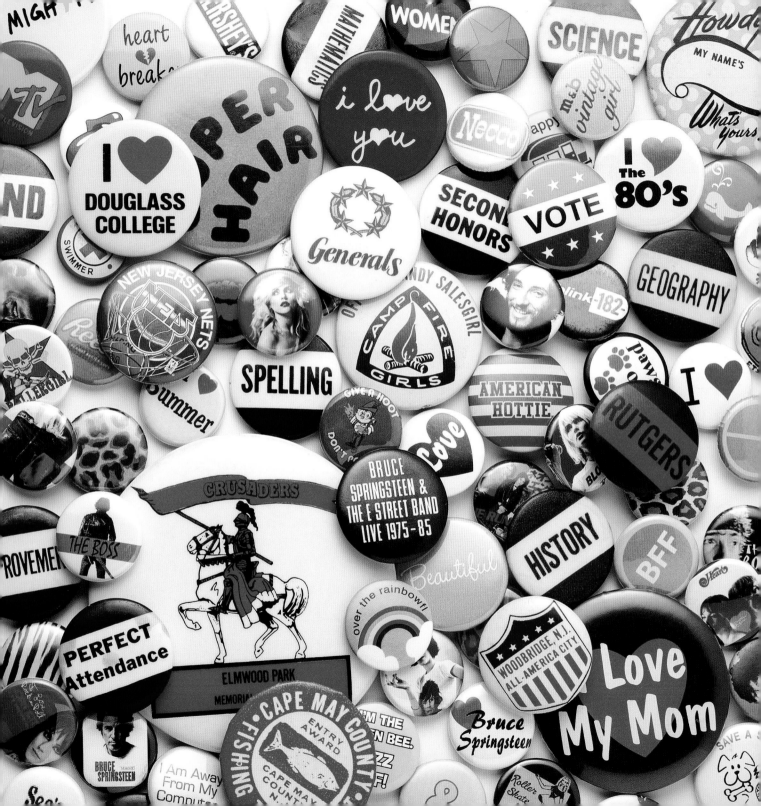

DEAR NEW JERSEY,

Oh my sweet petite peninsula! We love you for your high and low tide, your curvy coastline, your fields of sweet corn and ripe tomatoes. We adore your miles of malls, your Red Oaks and purple Violets, your grit, your glamour.

Love you for letting us in on the art of crabbing and the how-tos for eating a bucket of steamers…for the sand between our toes from Memorial Day 'til Labor Day…for the joy of winning the biggest prize on the pier.

Adore you, New Jersey, for introducing us to the Boss, big hair, and beauty parlors, for the global get-together of our neighbors and neighborhoods, and for apple cider donuts, drive-ins, and diners.

Thank you for making us feel like we were born under a lucky star, for a parkway ride with the windows rolled down, for being brave enough to choose Manhattan as our backyard, knowing we would always find our way back home.

Most of all, thank you for your larger-than-life attitude, for being the real deal, and for your count-on-me authenticity.

x, MARIE & BARRI

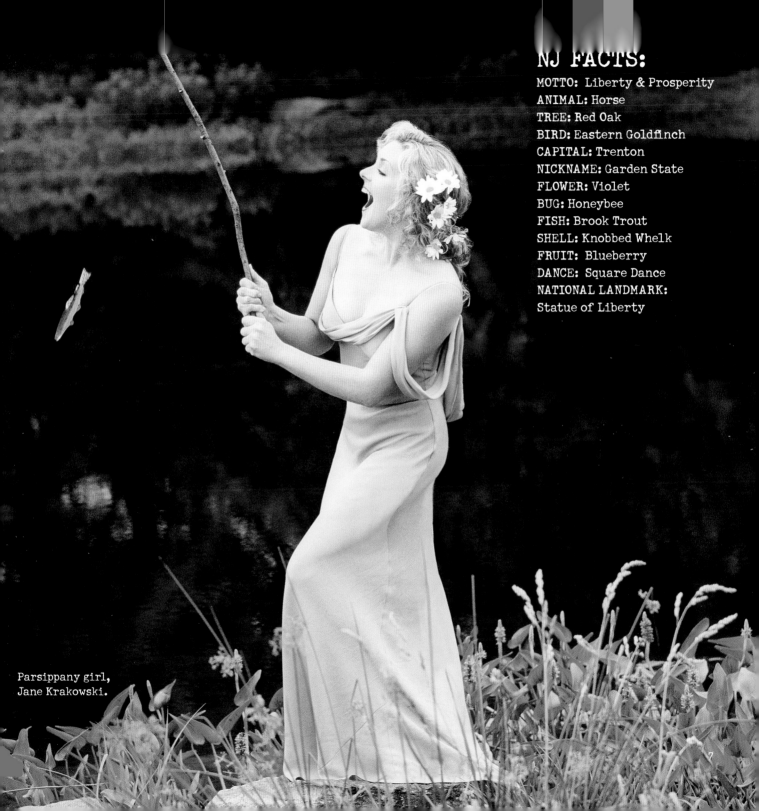

NJ FACTS:

MOTTO: Liberty & Prosperity
ANIMAL: Horse
TREE: Red Oak
BIRD: Eastern Goldfinch
CAPITAL: Trenton
NICKNAME: Garden State
FLOWER: Violet
BUG: Honeybee
FISH: Brook Trout
SHELL: Knobbed Whelk
FRUIT: Blueberry
DANCE: Square Dance
NATIONAL LANDMARK:
Statue of Liberty

Parsippany girl,
Jane Krakowski.

7

FOREWORD

BY JANCEE DUNN, AUTHOR

A few years ago, after I wrote a memoir about growing up in New Jersey, I was called into a meeting at my publisher in Manhattan. Thirty people from various departments were going to be there, and I was incredibly nervous. I was led into a conference room, and after I sat down, I put my hands under the table so that no one would see them shaking.

And then a woman leaned over to me. "I'm from West Orange," she said. The editor next to her chimed in that she grew up in Ramsey. And so it went down the table. A full one third hailed from the Garden State (which is fitting, considering it's the most densely-populated state in the country.) Immediately, I relaxed. I was among my people!

I say it loud and proud: I am a Jersey Girl. When I meet another girl from my home state, I feel an immediate kinship and recognize the special characteristics that make Jersey Girls unique: the inclusive warmth, the amiable sense of humor, the scrappy kind of fearlessness that I see over and over as I meet Jersey Girls in various fields. Jersey Girls are high achieving but stay down to earth. They have the willingness to work hard and the daring to try new things—a potent combination that has forged platinum-selling singers (Lauryn Hill of West Orange) and bestselling novelists (Elizabeth native Judy Blume.) Could Meryl Streep have been nominated for thirteen Oscars, had she not grown up in Summit? I think not.

But you don't have to be a famous Jersey Girl to be formidable. If you want something done, give it to one of us. Whether it's raising money for a pet cause or raising three kids, Jersey Girls get the job done. With our trademark cheerful capability and determination, we make it all seem easy, even when it's not. Ask any Jersey Girl and most of them have grown up holding a dozen "character-building" jobs. I have been everything from a waitress in a nursing home (the food was low-salt, low sugar, or puréed) to manning the drinks station at the Burger King in Madison.

Now I'm a journalist, and in my line of work, I meet a fair amount of people. Every single time I'm talking to a woman and feel an immediate connection, I find out that she too is from New Jersey. It's uncanny. There really is a common understanding, and, in my experience, an extra willingness to help each other out. I once landed a coveted job as a staffer at *Rolling Stone* magazine after I met a girl at a party in Springfield who told me she worked there. The next day I sent her my résumé. She promptly took it in to the office, put it on top of the pile, and talked me up (without even knowing me that well). I got the job. After I sent her flowers, she told me that a fellow Jersey Girl was responsible for her job.

It makes me insane when I see the narrow, clichéd way New Jersey Girls are often portrayed in the media. I grew up, very happily, in Chatham, and the special places I remember from my youth have nothing to do with tanning or hot tubs. I still visit many of them, particularly when I'm anxious about something. I find them soothing, not merely because they're familiar, but because they are gentle, comforting places. I love walking the trails in the Great Swamp National Wildlife Refuge, where I have spotted birds ranging from a Ruby Throated Hummingbird to a Great Horned Owl. Or I'll

catch a movie at the cozy, friendly, been-around-forever Chatham Cinema (my sister Heather once worked there as a teen and pilfered dozens of boxes of Junior Mints and Sno Caps). And my favorite place to eat—not just in the Garden State but quite possibly in the entire world—is the NM Cafe at Neiman-Marcus in the Short Hills mall (excuse me: the mall at Short Hills). It is my own Tiffany's: nothing bad can happen to you there. When you sit down with a contented sigh, a waiter hurries over with a tiny mug of consommé (consommé!) and a plate of yeast rolls with strawberry butter.

And if I'm really worked up about something, I'll head to the Museum of Early Trades & Crafts in Madison, a small, earnest institution visited, at one time or another, by every child in Morris County on a field trip. It's always a tonic to see an ancient wooden bowl, painstakingly carved by a Lenape Indian whose remains are probably squashed deep under Route 78 somewhere, and it "reminds" me not to waste time brooding over some silly "crisis" at work, because this, too, shall pass.

Granted, this is not to say I don't love going to the shore. An immediate way to bond with a fellow Jersey Girl is to tell her where you spent your summers. (I always headed for Point Pleasant, to Jenkinson's Beach, called Jenks by those in the know.) Recently I was at a stiff cocktail party and found myself next to a research scientist from Princeton. Somehow we brought up the shore—she spent summers in Manasquan—and within seconds, our formal facade dropped away as we animatedly compared favorite beach spots. Being from the Garden State will keep you grounded forever, no matter how fancy your job description becomes.

Of course, New Jersey is much more than the shore, and Jersey Girls are much more than the unrecognizable, one-dimensional figures I see on TV shows and movies. Then again, this image problem doesn't seem to bother my fellow Jersey Girls. Because you know what? They've got things to do. —Chatham, NJ

JERSEY NOTE
BY JUDY BLUME, AUTHOR

I'm a Jersey Girl from an era before big hair, malls, and brashness. My parents were born and raised in Elizabeth, and so was I. My father was a dentist there. My mother, a housewife (that's what we said before homemaker), loved to read. She took me to the Elizabeth Public Library on Broad Street, where I'd climb the steep outside staircase to the children's room. There, I would sit on the floor and pull books off the shelves. I'd not only turn pages looking at the pictures, but sniff the books, too. I loved the way they smelled, as warm and ripe as my "schmatta." This is where I fell in love with books. To this day, whenever a new book of mine is published, the first thing I do is sniff it—and it all started at the Elizabeth Public Library.

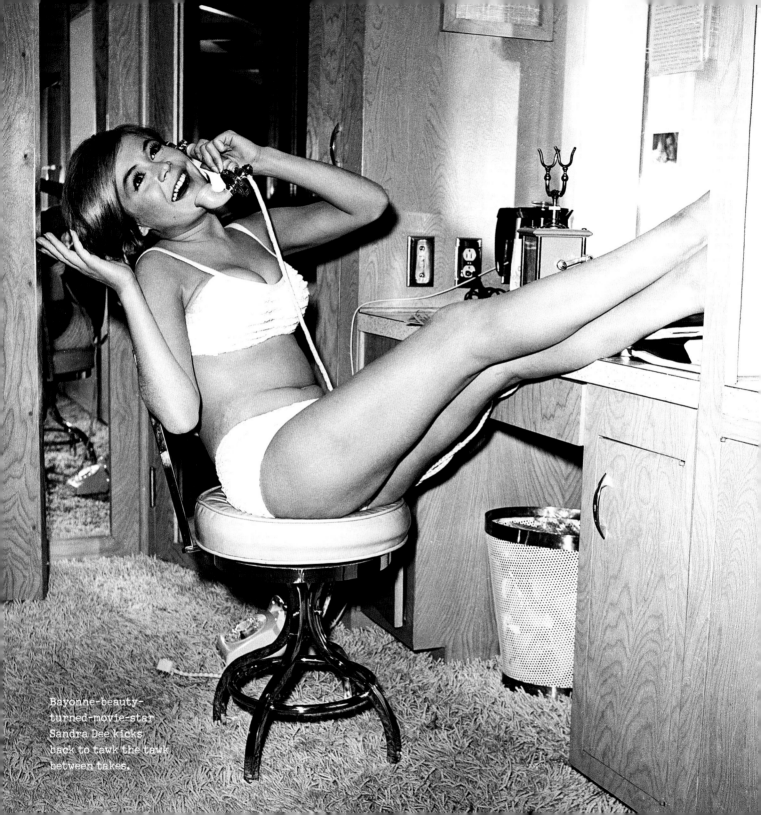

Bayonne-beauty-
turned-movie-star
Sandra Dee kicks
back to tawk the tawk
between takes.

TAWK

A JERSEY GIRL GLOSSARY

From the middle of Montclair to the coast of Cape May, all Jersey Girls are born with the gift of gab—in a good way, that is. It's a lexicon and lingo that is born from their very state of being. Or rather, their being from the State.

This certifiably recognizable "accent" puts an accent on a sprinkling of words here and there, peppering a conversation with not so much a studied dialect or overall twang, but more of a select pronunciation of Jersey Girl talking points.

And while often smugly and overtly portrayed as a mixed bag of banter from the five boroughs, and with all due respect to the lovely ladies of Staten Island, Jersey Girl speak is as one-of-a-kind as the Jersey Shore.

That is not to say that every Jersey Girl loves the "mawl" (though every Jersey Girl is "awl that"). And, of course, region by region there is a tweak to the speak. Yet within every Jersey Girl there is an endearing diction that is undeniably in-your-face the very minute a conversation begins.

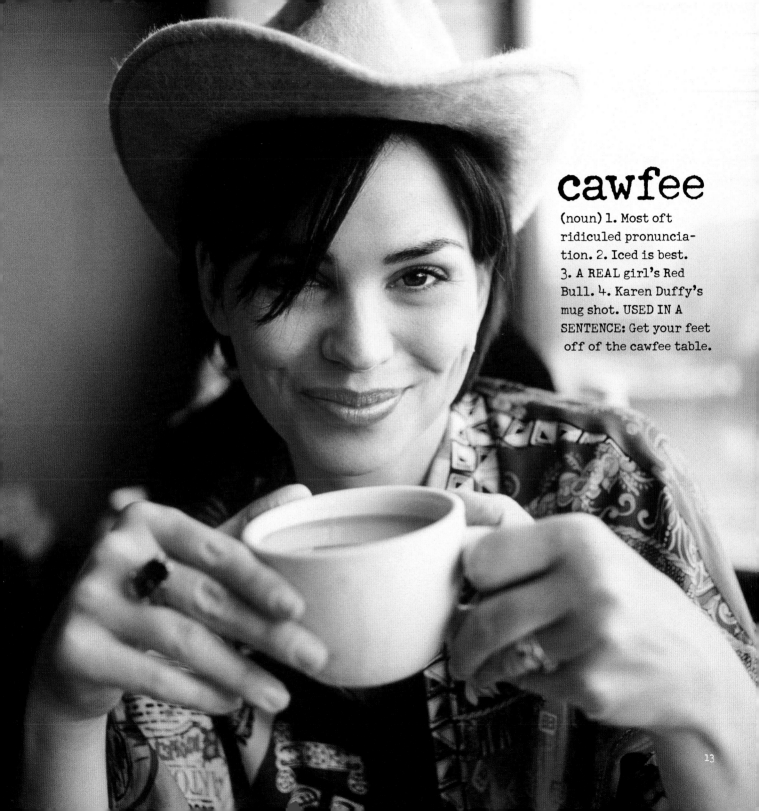

cawfee

(noun) 1. Most oft ridiculed pronunciation. 2. Iced is best. 3. A REAL girl's Red Bull. 4. Karen Duffy's mug shot. USED IN A SENTENCE: Get your feet off of the cawfee table.

jimmies

(noun) 1. Born in Brooklyn in 1917, embraced by
Jersey Girls ever since. 2. A.K.A. Sprinkles.
3. These mini rainbow-colored confections are
most at home when sitting all-delicious-like atop
a soft serve cone from Carvel. Local lore has it
that a chawklit variety does exist, but is rarely
sighted down the shore. USED IN A SENTENCE:
My cone was so covered in jimmies, I found a few
colorful runaways in my bra.

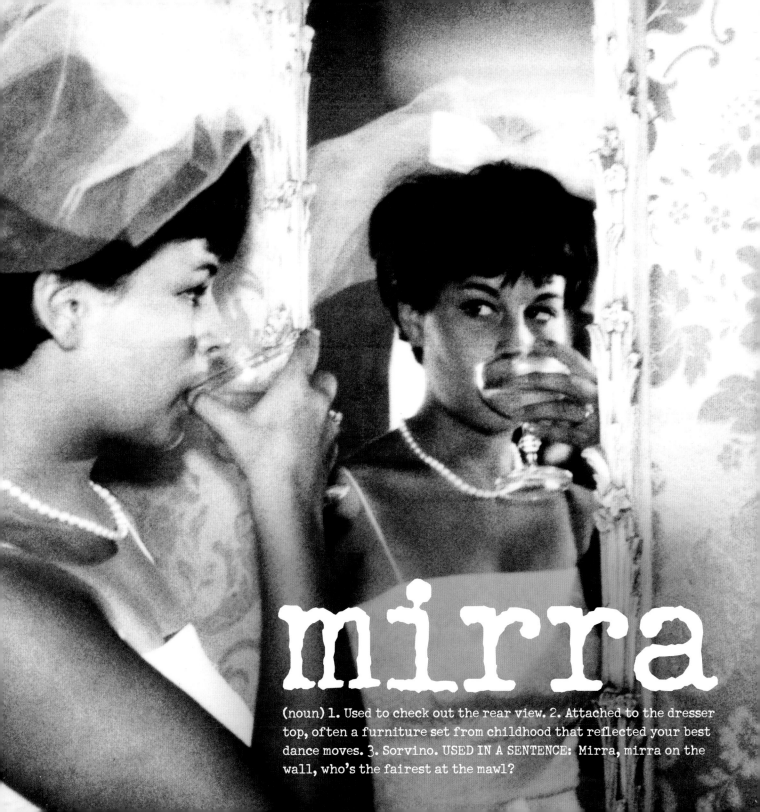

mirra

(noun) 1. Used to check out the rear view. 2. Attached to the dresser top, often a furniture set from childhood that reflected your best dance moves. 3. Sorvino. USED IN A SENTENCE: Mirra, mirra on the wall, who's the fairest at the mawl?

bawl (noun, verb) 1. A sphere of many styles used to play a myriad of sports learned in gym class like dodge, kick, base, basket, and volley. 2. A good cry over a bad breakup. 3. The ultimate amount of fun had by a group of JGs. USED IN A SENTENCE: We had a bawl at the boardwalk last night.

tal

(noun) 1. Often made of terry cloth, this poolside staple is predominantly used for drying off. 2. A portable prop used for staking claim to particular sections of sand at ocean's edge. Empowered with an even greater "no trespassing" vibe when accompanied by a large beach umbrella. 3. Comforting accomplice in yoga, on a treadmill, and when attempting to color one's hair at home. USED IN A SENTENCE: Don't use THAT tal—it's the one we use on rainy days to dry off the dawg.

pok-a-book

(noun) 1. Derived from the original "pocketbook."
2. A Jersey Girl accessory most commonly used
to tote about all things girly, like lip glawss
with a hint of sparkle, mawl money, and travel-
sized hairspray. 3. An item often confused with
"purse," "clutch," or "handbag." USED IN A
SENTENCE: Get me my pok-a-book and I'll give you
money for the ice cream truck.

dawg

(noun) 1. A Jersey Girl's favorite pet, often named with international flair (think "Pepe"), an adjective ("Fluffy"), or after a favorite band or musician (like Fergie, Blondie, or Ludacris). 2. Also used as a noun with adjective undertones for describing the guy who left you at the bar to dance with his old girlfriend. 3. This word's JG pronunciation is most often the word uttered that instantly declares a girl's state of origin. USED IN A SENTENCE: After two years of begging, I finally got a dawg to cawl my own.

chawklit

(noun) 1. A sweet admired and begged for in local corner stores around the Garden State. Also found as a fab flavor of frozen custard. 2. Think peanut M&M's, Twix, Charleston Chew (frozen), and foil-wrapped chocolate gold coins. 3. Melts in your mouth, not in your hands, but CAN melt all over your car seat if left to decompose while you are enjoying a sunny day at the beach. USED IN A SENTENCE: Here's a wet tal, you've got chawklit all over your face.

draw

(noun, verb) 1. Knob-bedecked bin that pulls out from the slots of a dresser or desk. 2. Used to store items like undies and bras, a month's worth of minty gum, a stack of tank tops, Mrs. Grossman's stickers, and a journal. 3. A word that calls for a shout out to the fun of "homonymy," as its meaning can also involve sketching, crayons, and colored markers. USED IN A SENTENCE: Finding an extra dresser draw in last summer's shore house rental was like trying to find a Jersey Girl in Poughkeepsie—it just ain't happening.

arringe

(noun) 1. A reddish-yellow Crayola staple. 2. An unfortunate shade of self-tanner when aggressively over applied. 3. A citrus favorite often used as a fruit basket filler and secretary lunch staple. Often schlepped north by the crate, or bushel, as a souvenir from "Flarida." USED IN TWO SENTENCES: Can you peel this arringe for me? I don't want to mess up my arringe nails.

mawl

(noun) 1. A place of worship. 2. Social Networking with a food court. 3. The original House of Style. USED IN A SENTENCE: I like that mawl because it has that pretzels-in-a-cup place and a Forever 21.

lip glawss

1. The official shine of the great State, available in a ridiculous array of drugstore varieties including a convenient roll on, sponge-tipped wand, and potted packaging. 2. Like the Milky Way, seen sparkling for miles from the halls of high schools, night-club dance floors, and boardwalks. 3. A pok-a-book staple. USED IN A SENTENCE: Can I borrow that strawberry lip glawss?

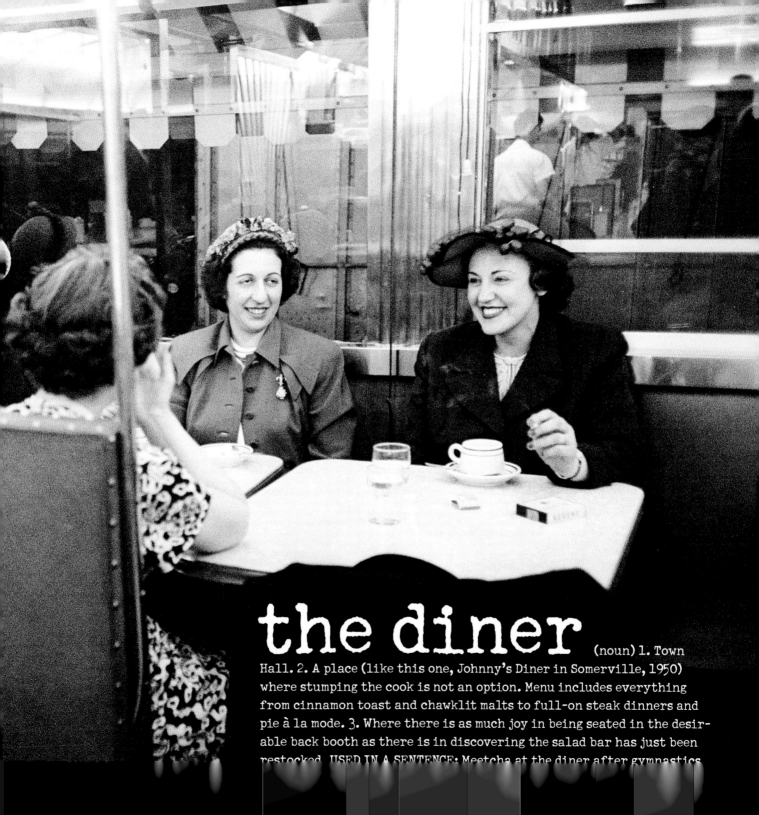

the diner

(noun) 1. Town Hall. 2. A place (like this one, Johnny's Diner in Somerville, 1950) where stumping the cook is not an option. Menu includes everything from cinnamon toast and chawklit malts to full-on steak dinners and pie à la mode. 3. Where there is as much joy in being seated in the desirable back booth as there is in discovering the salad bar has just been restocked. USED IN A SENTENCE: Meetcha at the diner after gymnastics

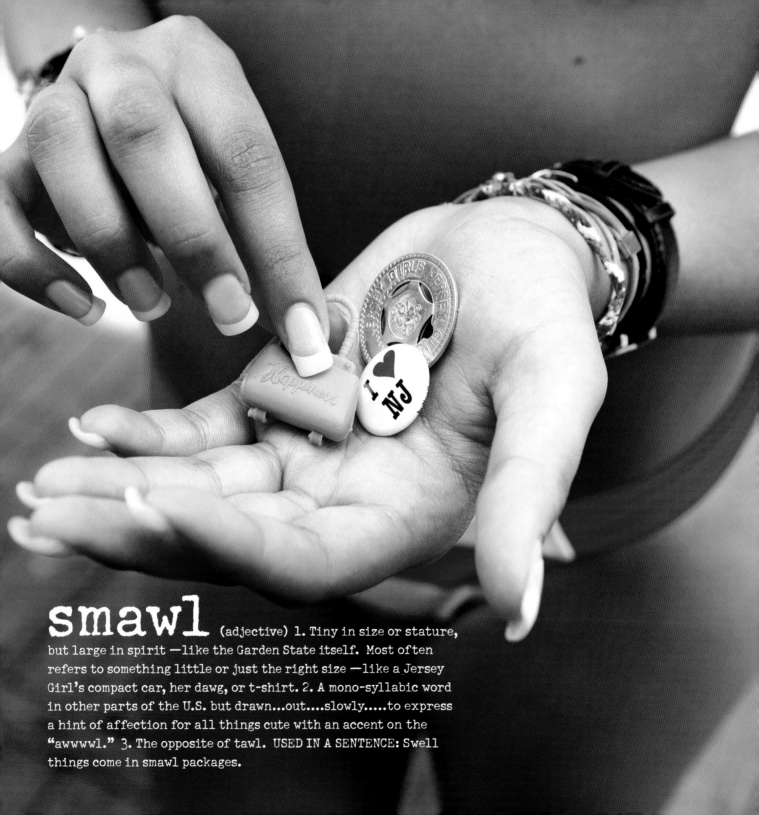

smawl

(adjective) 1. Tiny in size or stature, but large in spirit —like the Garden State itself. Most often refers to something little or just the right size —like a Jersey Girl's compact car, her dawg, or t-shirt. 2. A mono-syllabic word in other parts of the U.S. but drawn...out....slowly.....to express a hint of affection for all things cute with an accent on the "awwwwl." 3. The opposite of tawl. USED IN A SENTENCE: Swell things come in smawl packages.

jughandle

(noun) 1. A roadway ramp off to the right that allows a driver to make a left. This may seem odd to out-of-towners who suspect GPS issues, which in turn may cause traffic slow-downs

in and around designated jughandle areas. 2. Jersey Girls have very little pity or patience for jughandle novices and therefore it is recommended that anyone planning to travel through the Garden State take a quick course in jughandle usage and safety as the state is littered with them. 3. Part of a musical instrument that accompanies sleepy-eyed mechanical bears in Disney's Big Bear Jamboree attraction. USED IN A SENTENCE: I've taken part of the curb with me several times using that crazily curved jughandle on Route 1.

the city

(noun) 1. New York. 2. Where you're headed on any given Saturday night, via bridge or tunnel, in your finest mawl-bought attire, BFFs at your side, heels and glawss in tow. 3. A JG's backyard. USED IN A SENTENCE: We're going into the city tonight, wanna come?

Photograph by
Timothy White

BEBE NEUWIRTH

ACTRESS, SINGER, DANCER • PRINCETON, NJ TURNPIKE EXIT 9

HAPPIEST CHILDHOOD MEMORY OF GROWING UP IN THE GARDEN STATE? Sledding through the quiet woods behind our house out in the country, and swimming in the ocean, down the shore.

FAVORITE TEACHER? Georgine Hall was my English/ Shakespeare teacher at Princeton High School. She was a wonderful actress, and is a friend to this day.

DRAWN TO SEE YOUR NAME IN LIGHTS? I started taking ballet class at age five at the Princeton Ballet Society. I performed at McCarter Theater with the ballet school, and then as a member of the Princeton Regional Ballet Company. As a teenager I did a few "PJ&B" musical shows at McCarter (that's Princeton Junction & Back, a University musical review). That's when I started singing. I also spent a few summers building and running sets, hanging and patching lights, and even running them. This was all at Summer in Time, a beautiful little theater on the Princeton University Campus.

NEW YORK CITY GIRL? Manhattan was a glamorous, faraway place. We took trips there once a year or so, to see a ballet at Lincoln Center, the Harlem Globetrotters at Madison Square Garden, special things like that.

SHORE GIRL? I looooove the Jersey Shore! Our friends have a club in Sea Bright so that is where we went. Great waves, great body surfing, great hamburgers.

BIG HAIR BACK IN THE DAY? I was a teenager in the '70s, and I hung out with the "freaks," so big hair was not our thing. Long hair, center part. Frizzy then, frizzy now.

GOT A TAKE ON THE JERSEY GIRL AURA? Ah, the Jersey Girl Mystique. Who can say what makes a Jersey Girl a Jersey Girl (besides her geographic provenance)? It is an indefinable something, *a je ne sais quoi*. A half-smile, an arched brown, a tigress-kitten aura. We may indeed know the answer, but we're not gonna tell you.

KEISHA SPIVEY EPPS
SINGER, SONGWRITER · SOMERSET, GARDEN STATE PARKWAY EXIT 127

34

FAVORITE JERSEY MEMORIES? I love that New Jersey is a melting pot of many different cultures. I felt no segregation growing up there. The neighborhood was full of Asian, Italian, Hispanic, Jamaican, and African-American families and we weren't aware of any differences. We just all lived together beautifully. It was a rainbow of people! Everyone looked out for each other, neighborhoods were very close knit. We would check in on friends and neighbors, and there was a beautiful sense of community that I miss out here on the West Coast.

JERSEY EATS? I love the Somerset Diner and Mei-Mei's Chinese restaurant.

FAVORITE BOARDWALKS? I loved going to Wildwood for vacation. My mom would rent a cabin, and I will never forget the freedom I felt, of embracing nature in that way, listening to the birds. I try to instill this love of nature in my children. We would go into the brook and it was a fascinating adventure! I remember turning over the rocks, seeing the moss, the tadpoles.

BEST NJ ADVENTURE? I loved going to the Englishtown Flea Market with my family. It has to be the best flea market in the country, probably the biggest too. You could find anything you wanted there, toys and fresh fruits, and anything you can think of! I remember the long lines of cars leaving through the gates in the evening and dreaming of a return visit. I would love to bring my children there one day.

JERSEY MOMS ARE: We have a strength and endurance at the core, there is no "schtick" about us. Jersey Girls tend to be very family oriented which, in turn, instills a strong sense of being, of belonging. It is really hard to put the aura of a Jersey Girl into words, but one thing I can definitely say is that we are built to last!

JERSEY GIRLS VS. CALIFORNIA GIRLS? I think we both appreciate nature, and the finer things in life. Jersey Girls are definitely more aggressive, though. We can be pretty feisty! We are pretty much RAW, there's no black or white. We shoot straight from the hip—we've got lots of charcter and an abundance of layers. I have never known a Jersey Girl to take "No" for an answer.

HOW WERE YOU DISCOVERED? In our endless imaginations, my friends Kima and Pam and I dreamed of being a "girl group." Kathy Dukes was our vocal teacher. She took us under her wing and became the manager of our group—we called ourselves Total Opposites. That's how our careers got started. One day she told us she was taking us to perform somewhere but didn't tell us the details. We drove to a studio and knocked on the door and Puff Daddy answered. Being Jersey Girls, we had no inhibitions, just started singing, and took him by surprise! He later rang Kathy and said, "I want those girls on my label!" The rest is history.

We sang the hook and did the music video for Biggie's first single, "Juicy," and fans wanted us to make our own album, so we did. Our first single, "Can't See You," was put on the *New Jersey Drive* film soundtrack and from there on our careers were in full force. We toured Europe and Japan, performed at the Apollo Theater, the Meadowlands. I was particularly proud of a set we did with Biggie and Puffy for the televised *Source* magazine Awards.

FIRST NJ CONCERT? New Edition at the Meadowlands.

JERSEY JOBS? I always dreamed big as a young girl. My motivation was to help and take care of my mom, a single parent so she wouldn't have to struggle. I got a job as a newspaper girl, delivering the *Star Ledger* on weekends. I also worked at Shop Rite and Fava shoe store, where I remember singing while I worked.

MARRIED A BROOKLYN BOY, HUH? Yes! He challenges me, and I love that. At the same time, he is confident in my judgment when it comes to myself and our children. We were the best of friends back east. It was a friendship that was always meant to be more. He moved to Los Angeles some years before we reconnected. Eventually, I moved out to Los Angeles, too, to be with him and start our family. When we reconnected, he was everything and more. Hollywood hadn't changed him at all.

WARDROBE TEST

PROD. 1872 DATE 8/20/57

PART OF MELINDA

PLAYER SANDRA DEE

CHANGE No. 6

WORN BANDSTAND-
CHANGES CLOTHES

DESIGNER SEEN BY POLLY
THOMAS

MAKE UP: EYES ONLY

STYLE

GET YOUR JERSEY ON

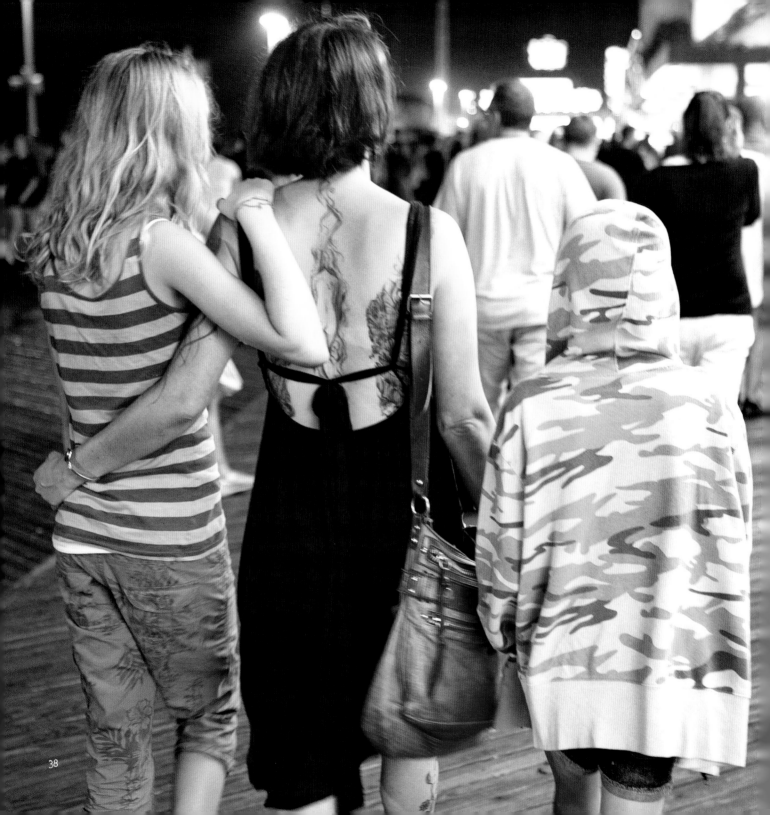

Not one to play the shrinking violet, a Jersey Girl's style is a studied mix-and-match masterpiece of **tough chic** and **outright glamour**. The brashy combination of these style polar opposites often have a sprinkling of **sparkle and glitz** that instinctively pull a look together. JG style involves a little mall madness, couture cool, and a lot of attitude, with a **POW** of her own personality mixed right in.

From local **fashionistas** in high-school hallways, to Hollywood's hottest stylists and superstars, it is a stand-alone style that never fails to inspire.

Camden girl, Kelly Ripa.

"**the perfect metaphor** for a Jersey Girl's personality is her closet. In my closet, hanging next to my D&G coat is my 1980s denim jacket covered in pins. Likewise, my Manolos are keeping company with a bin of colorful flip flops, and my jewelry box stores both pearls and an array of ankle bracelets and toe rings ready for action on the Ocean City beach." —Marianne, Berkeley Heights

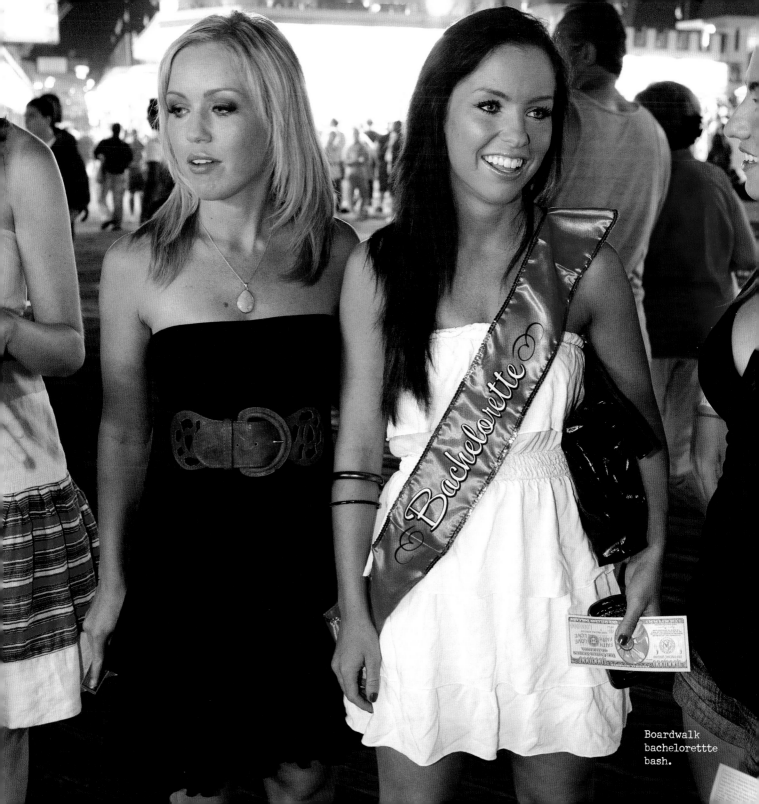

Boardwalk
bachelorettte
bash.

"IT IS A 'DON'T MESS WITH ME,' ROCK 'N ROLL STYLE THAT APPEARS ON THE FLIP SIDE OF THE JERSEY GIRL STYLE SPECTRUM, A TOUGH AND SEXY, RAW AND EMOTIONALLY CHARGED STYLE, TEMPERED WITH A VULNERABLE ALLURE THAT TRANSLATES INTO SOMETHING BOTH PROVOCATIVE AND POWERFUL." –JORGE RAMON, CELEBRITY STYLIST

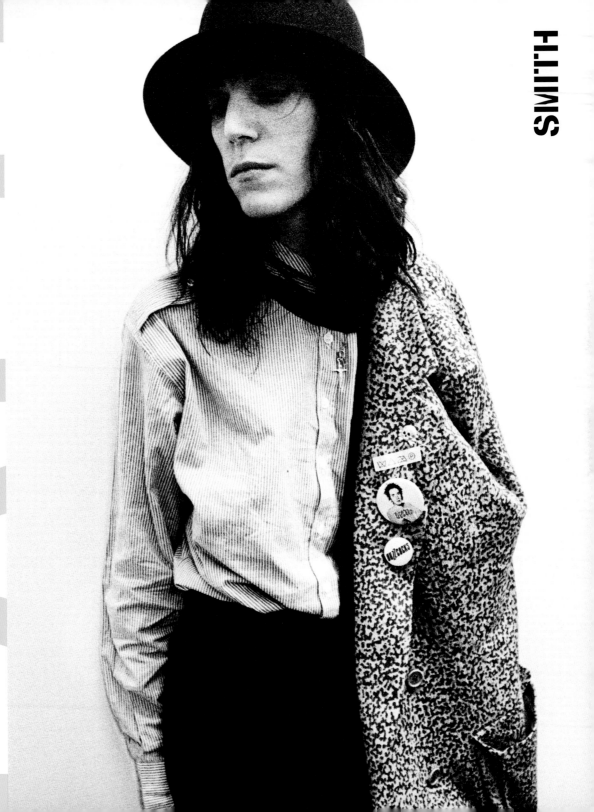

PATTI

SMITH

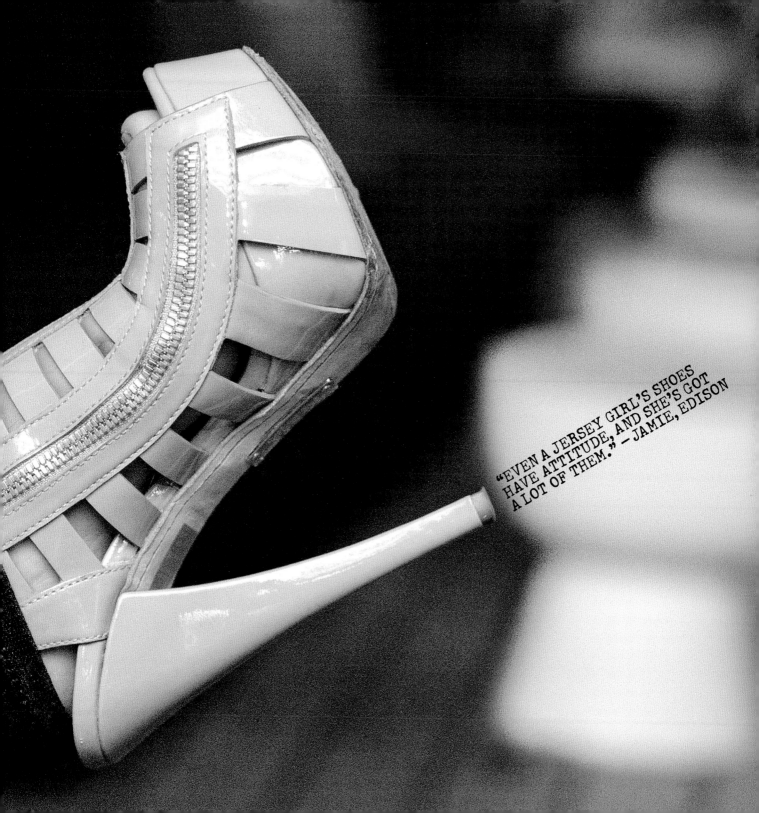

"EVEN A JERSEY GIRL'S SHOES HAVE ATTITUDE, AND SHE'S GOT A LOT OF THEM." — JAMIE, EDISON

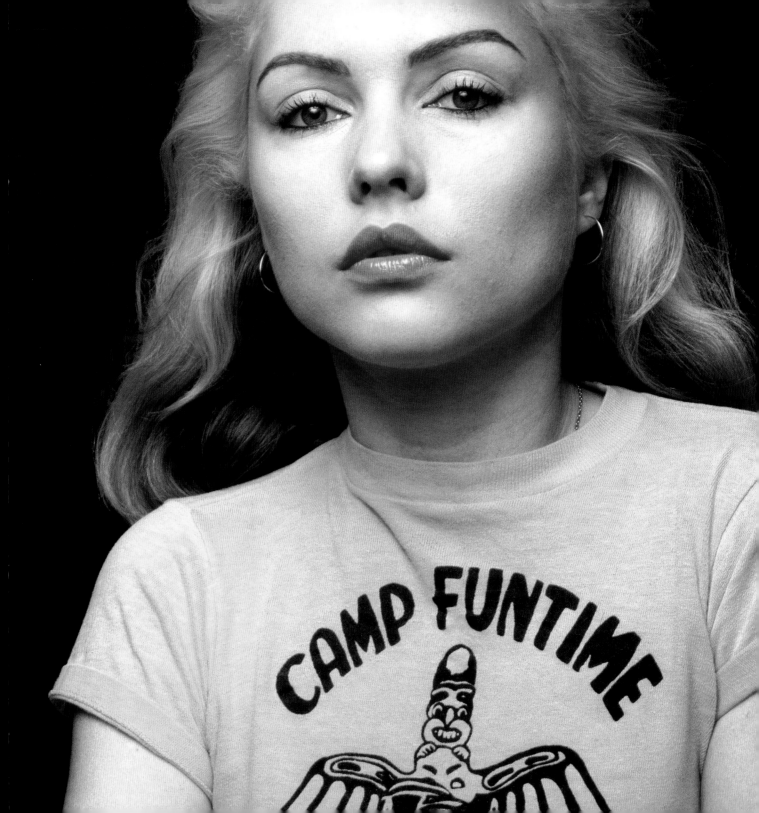

"Debbie
←Harry

is the best
 Jersey Girl
to have ever lived.
 She is the marker
upon which
 we all measure
ourselves.
 So cool.
 So street.
High art & fashion.
 I dug her
 whole vibe and
 what she was able
to create."

-Vitamin C→

47

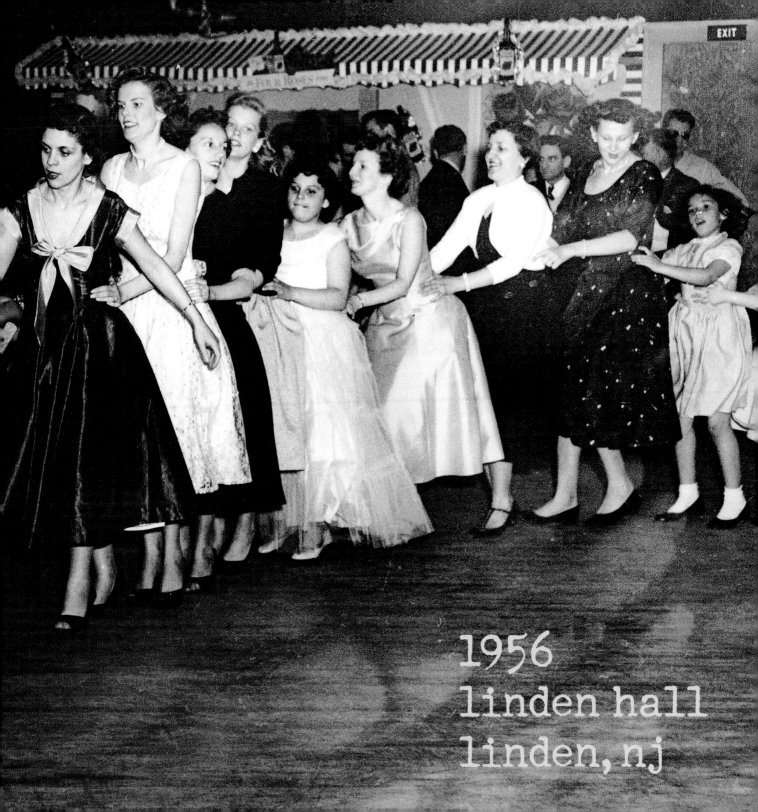

1956
linden hall
linden, nj

JE NE SAIS *coif*

As revered and intriguing as Medusa's hair (minus the whole snake and winged-horse thing), a Jersey Girl's hair is perhaps as iconic as her accent.

Hair dos and the occasional do "knots" are identified as the standard of beauty for Garden State girls, calling them out like a state-issued ID card.

Tagging along with a relative to her standing appointment at the beauty parlor is often where a Jersey Girl's big hair education begins. Despite Aqua Net inhalations and too much Coke before dinner, it was the hanging around at the parlor while Aunt Ruth got the perfect fall pinned in that first introduced many Jersey Girls to the empowering presence of hair-up-to-there. With the buzz of bulbous overhead hair dryers and the din of local gossip in the air (well, Aqua Net was still in the air too), Big Hair 101 was in session.

While the tools and tones of the high-hair trade have changed with the times—think poodle perms, pageant hair, and the Big Bang Theory—the notion that a Jersey Girl's hair should be as big as her personality has never waned. She moves on from parlor games to primping for the perfect yearbook photo, mastering the art of the spray spritz and getting a good night's sleep in Velcro rollers. And while the cut and color of the moment can come and go, the largesse of Jersey Girl hair will forever wave.

51

hair

to

there

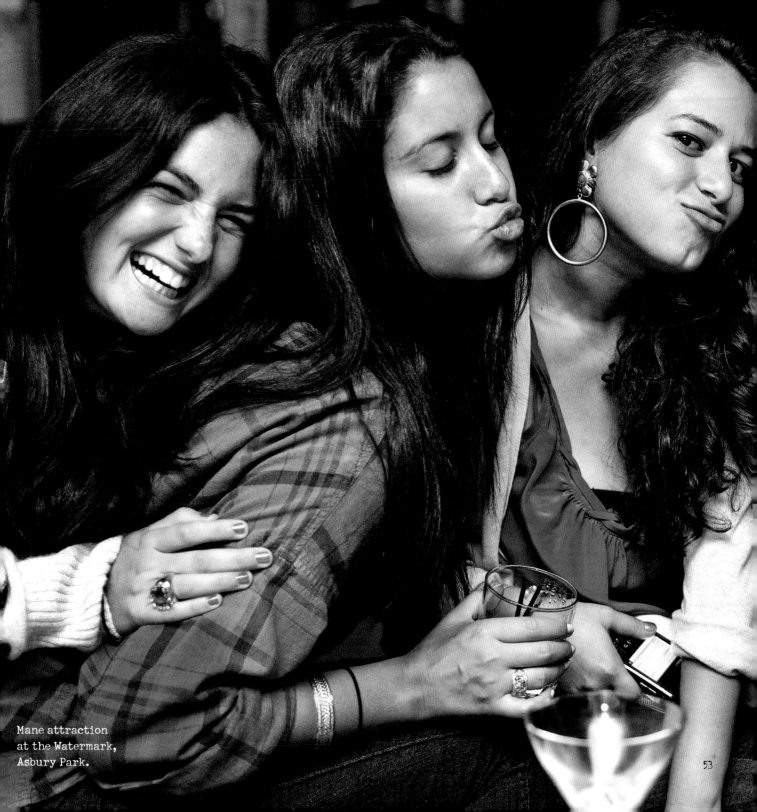

Mane attraction
at the Watermark,
Asbury Park.

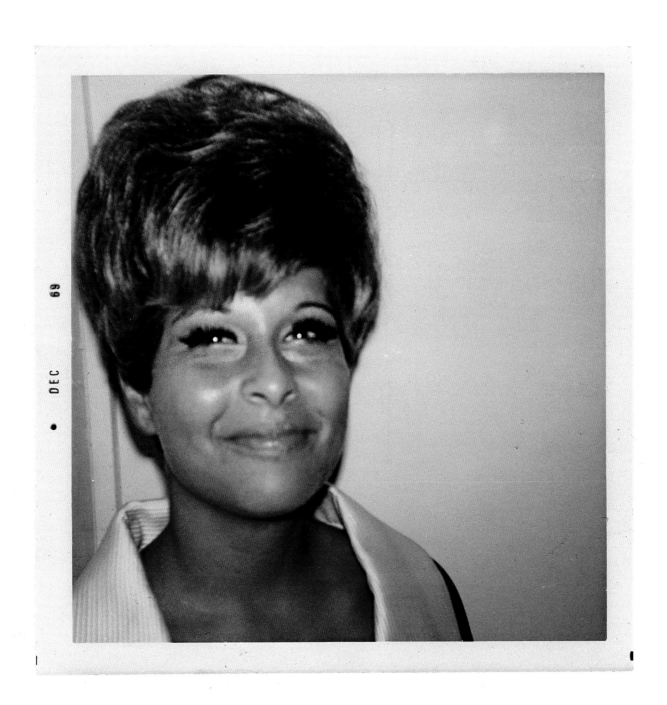

FROSTED BLONDIE, 1969.

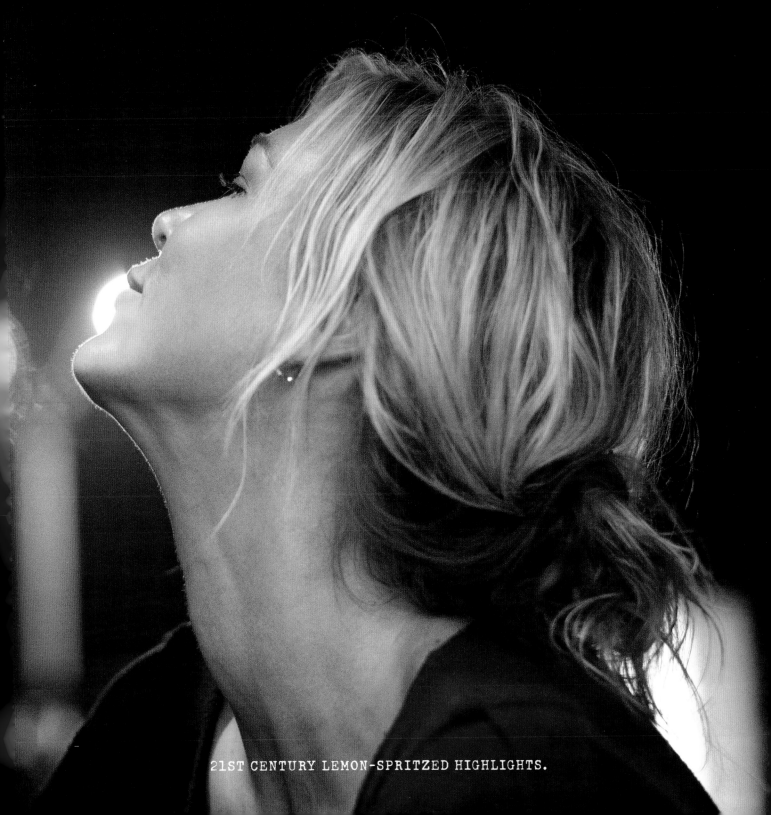

21ST CENTURY LEMON-SPRITZED HIGHLIGHTS.

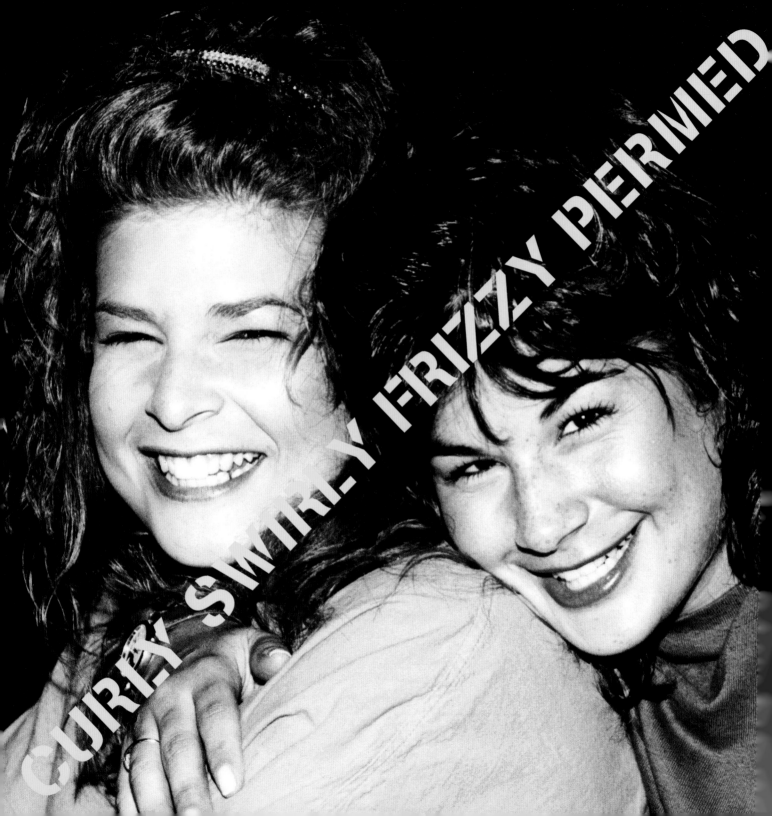

THE BIGGER THE HAIR THE CLOSER TO GOD

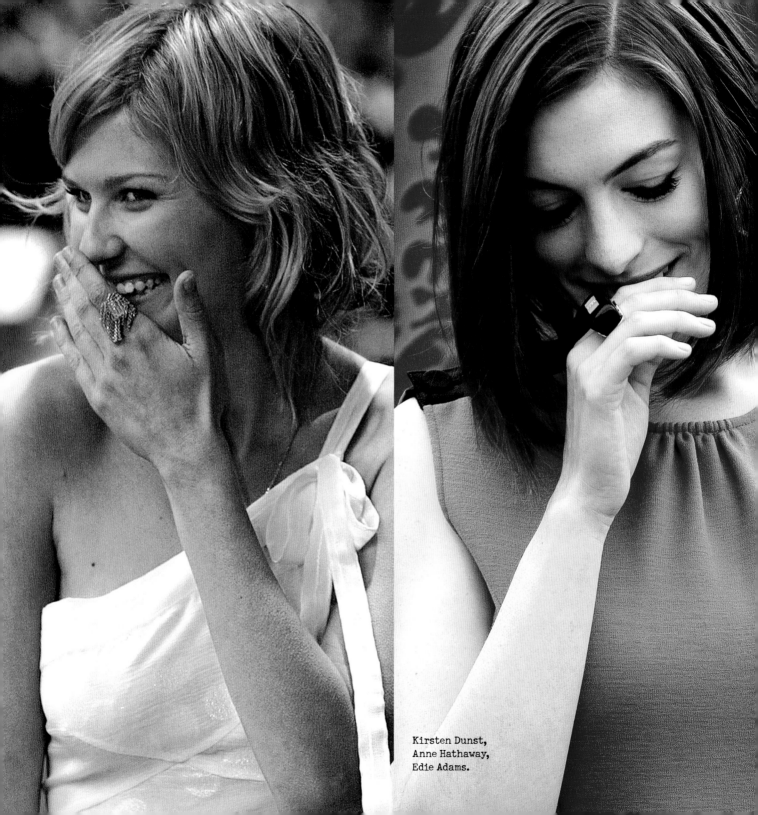

Kirsten Dunst,
Anne Hathaway,
Edie Adams.

"People respond to Jersey Girl confidence. They have an attitude and drive that is palpable. They are the new frontier of strong women and are sexy because of their power. That's what makes them all such stars."

—Wayne Scot Lukas, Designer/Celebrity Stylist

File this one under the "always look fab at the mall" tab! Singer, dancer, actress, and Jersey Girl Ashley Tisdale was discovered at the Monmouth Mall, just a stone's throw from her house in West Deal. You really can find ANYTHING at the mall, even an agent.

AHH THE MALL

Welcome to a Jersey Girl's playground. While hardly a skip from one mall to the next, each mall stakes claim to a certain distinctiveness. Some secure bragging rights with the best frozen yogurt shop, others offer a state-of-the-art theater and boardwalk-like arcade. Some, grounded by a magnificently fancy department store, set the standard for where to shop when, well, a Jersey Girl needs something fancy. Celebrated as prominent landmarks with highly visible signage dotting the highways (many with exclusive jughandle exits), they all do serve as microcosms of style as shops and Jersey Girl shoppers take part in an elaborately stylish, sometimes dramatic display of real-life runway, old-school social networking, and in-your-face performance art.

Jersey Girls share fond memories of their first mall drop-off, the day they were set free like a fawn into the forest with a few dollars in their pocket to repeatedly pop in and out of shops and restaurants in a quest for simply being seen on their own with a trendy shop's bag in tow. It was a day to whip through the rounders for five-buck-finds, get your ears pierced again, or stake out the best food-court combo.

Keen, too, are the memories of back-to-school shopping like a fashion editor, using magazine tear sheets as guide maps for how to work a look that first day back. Come Labor Day weekend, an Indian Summer weather pattern means nothing to Jersey Girls who are determined to wear new crewneck sweaters and wool caps to orientation in proud recognition of the season's latest English newsboy trend.

Growing up in the state that is home to the most malls per square mile means mall-as-mecca. As women, the hunting and gathering continues with mall outings that promise catch-up time with a friend, perhaps a fresh take on a new season, and an all-around feeling of simply being home.

omg saw uk who @ mall. get heree now!! tots, be there in a bitt. meet u @ nail place(:

WE *heart* MAKEUP

Whether it is a simple hint of all-over shimmer or a high-drama swath of multi-media eye-and-cheek-color, Jersey Girls can work their makeup like no other breed of broad. With makeup experimentation and application prioritized at the top of her daily to-dos, a Jersey Girl is most often quite the expert at knowing what is trendy and new, and what is tried and true, on the drugstore shelves and at the makeup counters.

From the start, a Jersey Girl is right at home among the samplings found at the local pharmacy. It is the allure of Love's Baby Soft and the high shine of Maybelline Kissing Slicks, and the colorful pots of polish that draw her in, with future visits turning to car paint colored liners and lush lash tints. And while she will forever partake in this allowance-friendly fare, there will undoubtedly come a day in every Jersey Girl's life when she takes a dip into department-store counter culture, trying out a swipe of red gloss here, or a sparkly shadow there, on one mall excursion or another.

Is it the perfectly coiffed make-up girl that lures her in with a lesson? Or perhaps it is the gift with purchase that makes it all worth a peek? Whatever the initial catalyst, a Jersey Girl will always remember the coming-of-age moment when her first fancily packaged and professionally personalized jar of moisturizer made its way out from behind the counter along with real makeup brushes designed specifically for her getting-ready regime. Tucked inside the store's luxe logo bag with tissue paper popping out of the top, a Jersey Girl immediately senses a thrill that is on par with perfecting parallel parking and skating a figure eight at the pond.

This thrill never wanes as a Jersey Girl's love of cosmetics and skincare products forever keep her at the front of the line for a swipe and sample of what is new and noteworthy. She can go over the top but never under the radar with an array of makeup moods that make the grade at the PTA and set the bar at the bar. From Rutgers grad and *Today* show co-anchor Natalie Morales's classic take on making up, to the sometimes high-drama eyes of Jersey Girl Christina Ricci, the JG take on putting-on-your-face suits the state's cast of characters.

And while luck and lessons—and free samples —are all a factor, there is no denying the seamless slight of hand and all-out flair present in every Jersey Girl's way with makeup.

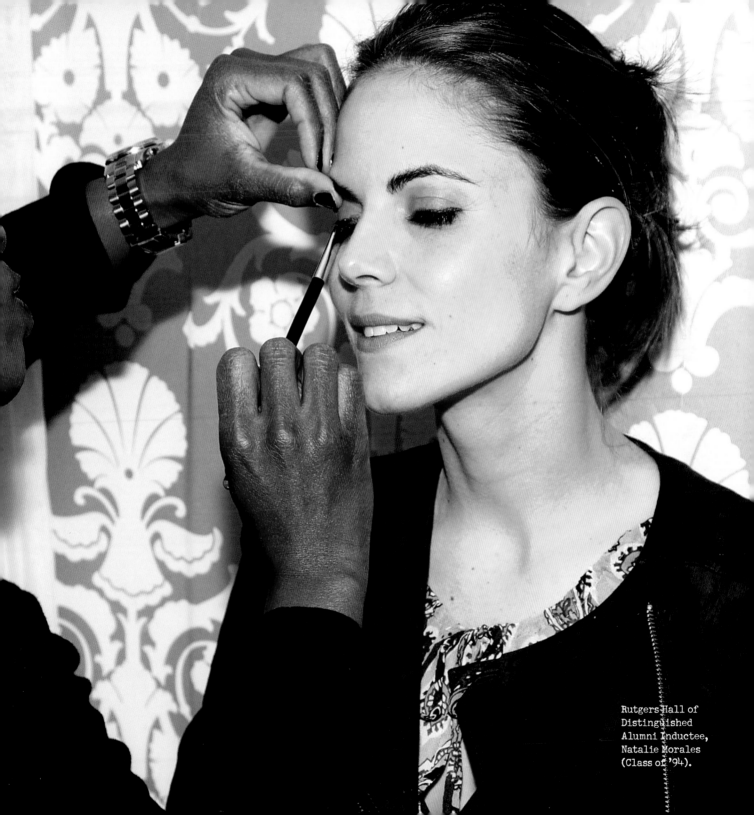

Rutgers Hall of
Distinguished
Alumni Inductee,
Natalie Morales
(Class of '94).

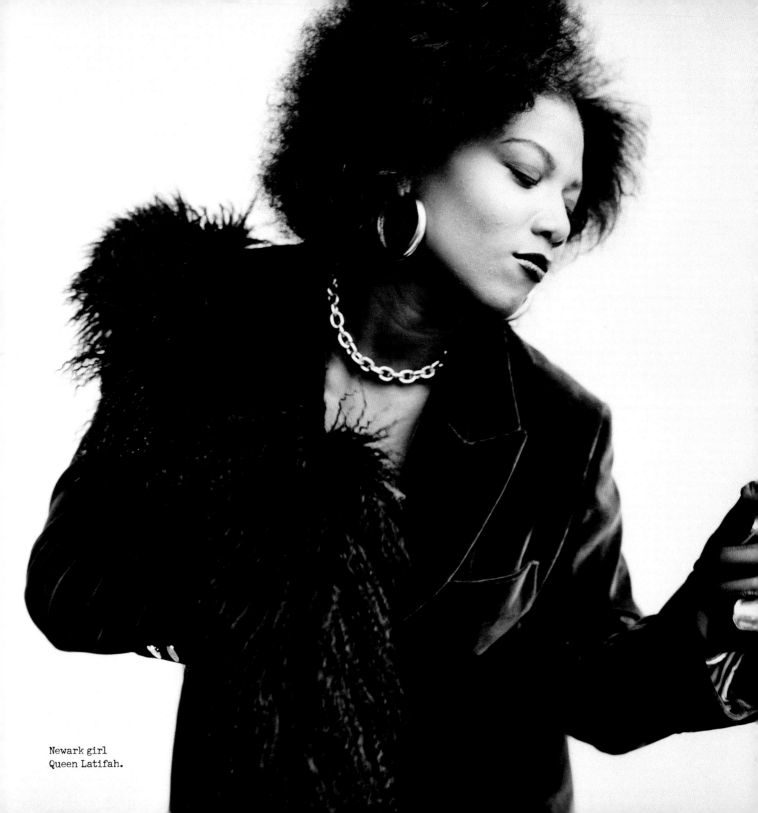

Newark girl
Queen Latifah.

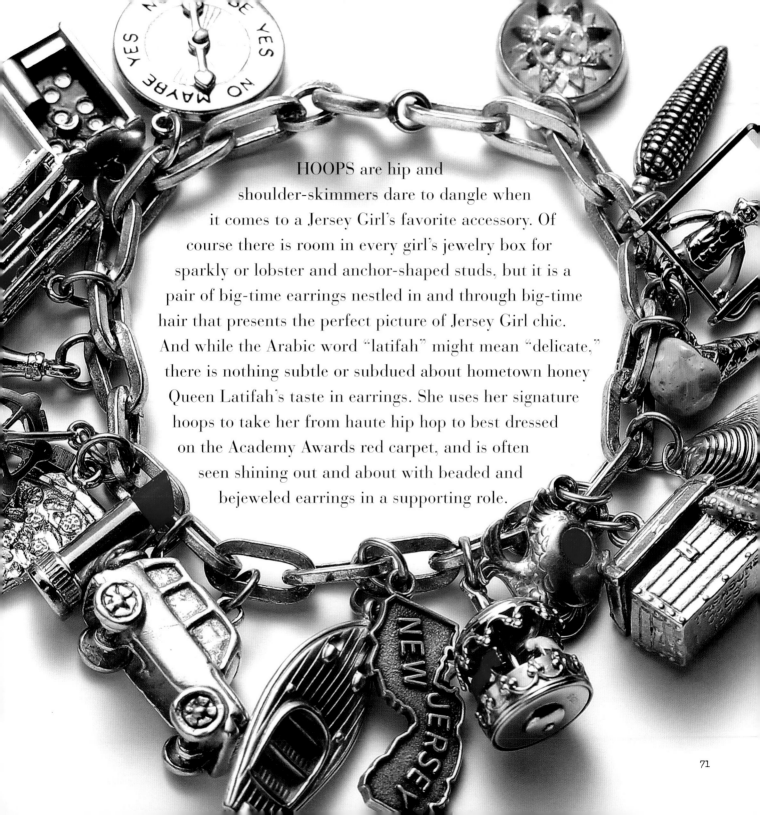

HOOPS are hip and shoulder-skimmers dare to dangle when it comes to a Jersey Girl's favorite accessory. Of course there is room in every girl's jewelry box for sparkly or lobster and anchor-shaped studs, but it is a pair of big-time earrings nestled in and through big-time hair that presents the perfect picture of Jersey Girl chic. And while the Arabic word "latifah" might mean "delicate," there is nothing subtle or subdued about hometown honey Queen Latifah's taste in earrings. She uses her signature hoops to take her from haute hip hop to best dressed on the Academy Awards red carpet, and is often seen shining out and about with beaded and bejeweled earrings in a supporting role.

ode
TO THE POKABOOK

A Jersey Girl's admiration for all things pokabook begins at an early age. Essentially seen as a leather, vinyl, or canvas appendage on a teacher, mother, aunt, or babysitter, the pokabook is a symbol of style and power, even when devoid of a fancy French or Italian label. A young girl is instantly assured of being in capable hands when spying a pokabook on the arm of the Jersey Girl in charge.

Not a clutch, nor any variety of a delicate night-on-the-town bag, a pokabook is most often carried about by its strap, nearest the elbow of a slightly upturned forearm. When considering the nature of a pokabook, one must think Bea Arthur and Aunt Bea meets Jackie O. and Holly Golightly—a Jersey Girl talisman that is hardy and practical, yet regal and ladylike. Need a notepad, pen, or postcard postage stamp? Got it! Want a stick of gum, a peppermint, a licorice stick? Got it! Looking for aspirin, a roll of quarters, ice cream shop coupons, or a full-on makeover? Count on a Jersey Girl to have all of the right fixin's when her pokabook is in tow.

A first summer job is usually the catalyst for acquiring a real deal pokabook, though the arrival of back-to-school fashion magazines in the mailbox and on the newsstand, brimming with photos of the best new bags, can bring on the dire need to own a fabulous pokabook of one's own. These style-making instincts snowball into a Jersey Girl's lifelong obsession with coveting, acquiring, and forever archiving her pokabooks and all they come to represent.

A Jersey Girl's pattern of thinking—you can never go wrong with a little animal print.

girls gone wild

Connie
Francis

"JERSEY GIRLS MADE THE '80S THE '80S AND THEY'RE NOT LETTING IT GO."

—JESSE GARZA, VISUAL THERAPY

Striking a pose at the Bayonne Country Club.

ANNETTE ROSARIO

MODEL, TV PERSONALITY · JERSEY CITY, NJ TURNPIKE EXIT 15E

WHICH HIGH SCHOOL DID YOU GRADUATE FROM? Marist High School.

MOST MEMORABLE JERSEY VACATION? Spending a couple of weeks in a rented house in Seaside Heights—boardwalk, beach, pizza—every day.

FAVORITE NJ HANGOUT AS A KID? Country Village Park, Jersey City.

FAVORITE DINER AND DISH? The Colonette for their mozzarella sticks.

FAVORITE WAY TO CELEBRATE A HOLIDAY IN NJ? On the rooftop watching Fourth of July fireworks over the Hudson River.

FAVORITE MALLS? Before I could drive it was the Hudson Mall because the bus would take me right there. Now I like the Short Hills Mall and the Garden State Plaza Mall.

FAVORITE JERSEY BAND? Bon Jovi then and still Bon Jovi.

HOW WERE YOU DISCOVERED? My cousin invited a friend, Jeffrey Kolsrud, to dinner one night. He happened to be the owner of the very successful modeling agency, Q Management. On that day my modeling journey began. I landed my first big job two months later.

WHEN DID YOU KNOW YOU HAD "MADE IT"? When I saw myself larger than life on a Times Square billboard. My most proud modeling achievement was being the face of L'Oréal True Match. I think that is every model's dream! Just thinking about it gives me goose bumps.

WHAT IS IT LIKE BEING A JERSEY MOM? Well, I have been blessed with two beautiful children, children who will always know what the mall is, children who will always know the difference between the Jersey Shore beaches, and who will always know what it is like to have a backyard. My children will always know their neighbors and the owner of the corner store. My mom chose to raise her children in NJ and so have I—Jersey is in my heart. No matter where I go, I will always be a Jersey Girl.

FAVORITE JERSEY GIRL? There is only one Jersey Girl that will forever be my favorite and that is my mom! She brought us to NJ to give us a better life and I thank her every day for making that choice. Thank you, Mom!

DENA BLIZZARD

COMEDIENNE · WATERFORD, NJ TURNPIKE EXIT 4

ELEMENTARY SCHOOL BFF? Lisa Weissman.

FAVORITE DINER, FAVORITE DISH? Milkshakes with my girlfriends at the Palace Diner whenever a guy broke up with me.

FAVORITE BOARDWALK? Ocean City.

FAVORITE BOARDWALK FOOD? Funnel Cake.

FAVORITE NJ DAY TRIP? Going with my family to Fantasy Island on Long Beach Island. I rocked at the video games and the crane game. I think I won a hundred stuffed animals from one machine.

FAVORITE JERSEY COCKTAIL? Anything with alcohol in it.

FAVORITE MALL STORE OR TRADEMARK MALL OUTFIT? My girlfriends and I hung out in Spencer Gifts. I wasn't very trendy but I worked the headband and/or side ponytail look.

SUMMER JOB IN JERSEY? My first job was picking blackberries on a farm down the street from us. Right from there I went to the WaWa and spent my money on candy. After that, like many Jersey Girl teenagers, I worked at the diner.

BIG HAIR? My Mom thought it was fun to perm my hair. This was not a good idea. When I first started competing in the Miss New Jersey pageant, I was in college and had a big butt. My girlfriends and I thought if we made our hair bigger our butts would look smaller. Unfortunately, it really just made us girls with both big hair and big butts.

JIMMIES OR SPRINKLES? Jimmies, of course.

JERSEY GIRL JE NE SAIS QUOI? We are honest. I love that about Jersey Girls. You may not like what I have to say, but I am honest. At Miss America, the girls from all over the country were so appropriate. I loved that Jersey didn't have to live up to that expectation. People expect us to be straight and to the point. It is very freeing.

BEST THING ABOUT BEING A JERSEY GIRL? I love that New Jersey has a reputation. You can go anywhere in the country and if you tell them you are a Jersey Girl, it means something.

I was asked to perform in New Hampshire one night and as I was driving to the gig I saw one mansion after another. I was a little intimidated and said to the booker that I wasn't really sure that this was going to work. I told her that I was "Jersey funny" and that I wasn't sure that my comedy was going to translate to being "New Hampshire" funny. She said not to worry, that "Jersey funny" was funny everywhere. If I said I was "Wyoming" funny, then she might be worried. I loved that.

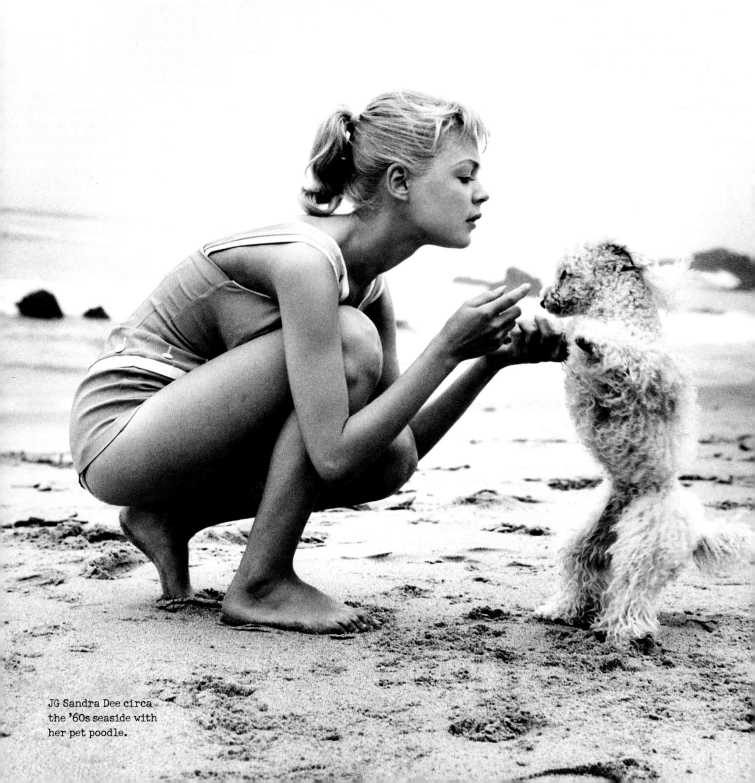

JG Sandra Dee circa
the '60s seaside with
her pet poodle.

SHORE

GOING DOWN IN STYLE

Whether it is a Jersey Girl's flirty flip-flop through the echoing Asbury Park convention hall, or a turn at playing music video back-up beauty for Bon Jovi in Seaside Heights, the Jersey Shore boardwalk has long held the distinction of being THE place to walk the walk and tawk the tawk.

It is the place where a Jersey Girl is drawn to perfect the celebrated skills that all true Jersey Girls ultimately possess. High score in Skee-ball? Check! Perfect photo booth pout? Got it! Denim cut-offs cut-just-right? Wearin' 'em! A brush with Bruce? Three times at Stone Pony! Don't mess with my fab hair? Whaddya think?

Many believe it is the perfect blend of salt-air mist and salt-water taffy—and a heavy dose of attitude—that combine for the perfect coastline cocktail of Jersey Girl sass and style. Some even sense a Jersey Shore magnetic field that draws true Jersey Girls in from turnpike exits statewide. Whatever the theory, there is no room for any diss or doubt to the fact that Jersey Girl boot camp begins down the shore.

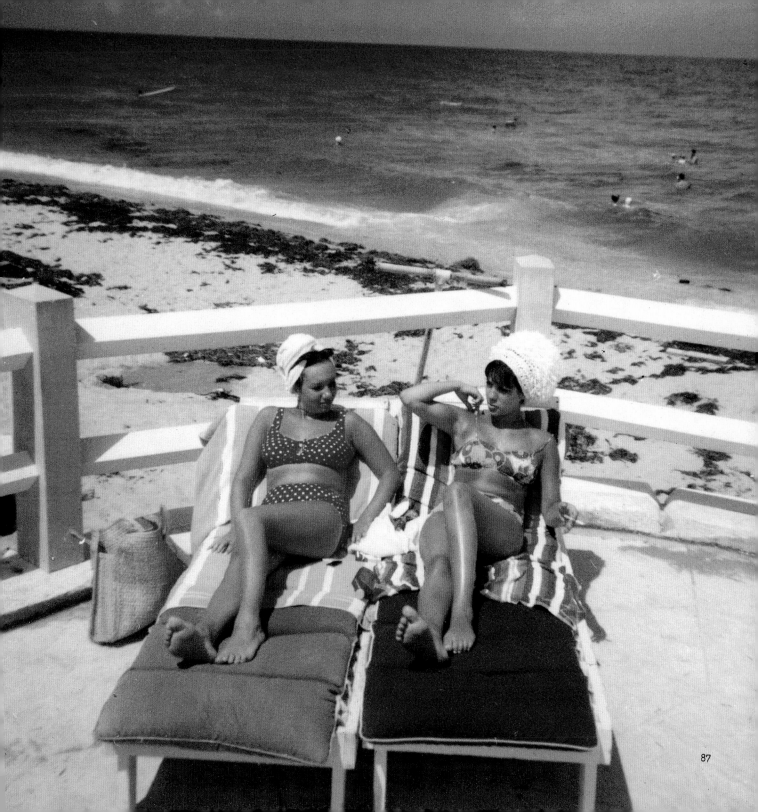

yport keansburg atlantic highlands sandy
ok redbank rumson seabright longbranch deal
lenhurst loch arbour ocean grove lake como
lmar spring lake sea girt brielle manasquan

me
rs
ld
go
re
to
ill
he
ck
nd
th
le
re

intpleasant bayhead seaside heights lavallette
land beach barnegat light loveladies surf city
ipbottom beach haven atlantic city sea isle
ty avalon wildwood stone harbor cape may

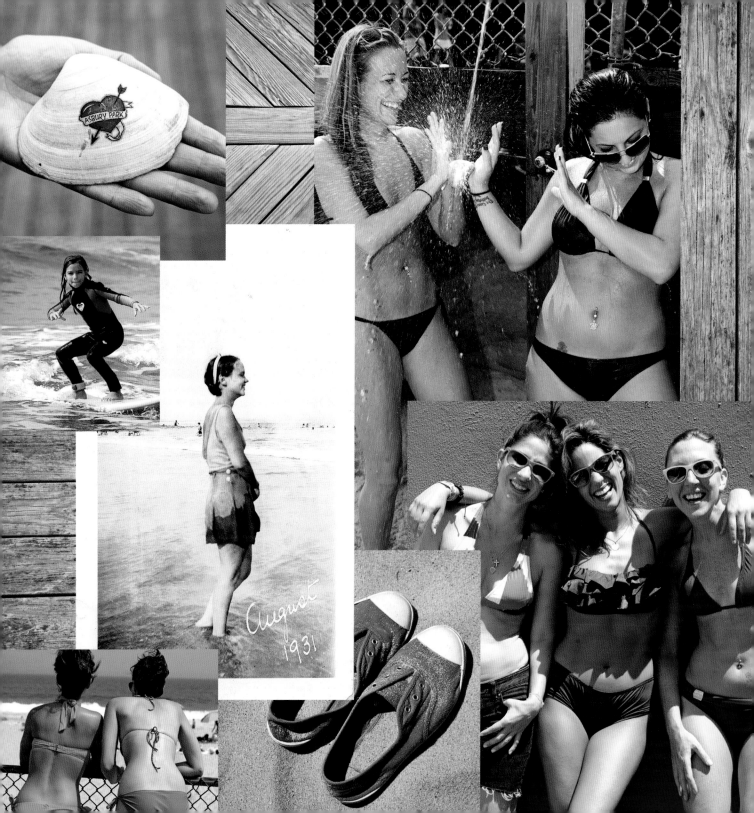

August
1931

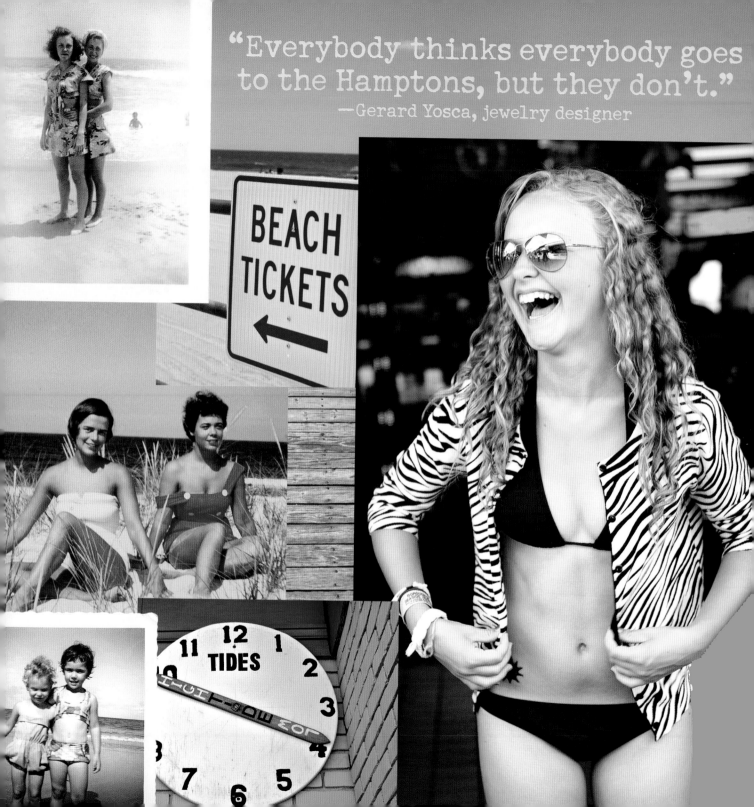

"Everybody thinks everybody goes to the Hamptons, but they don't."
—Gerard Yosca, jewelry designer

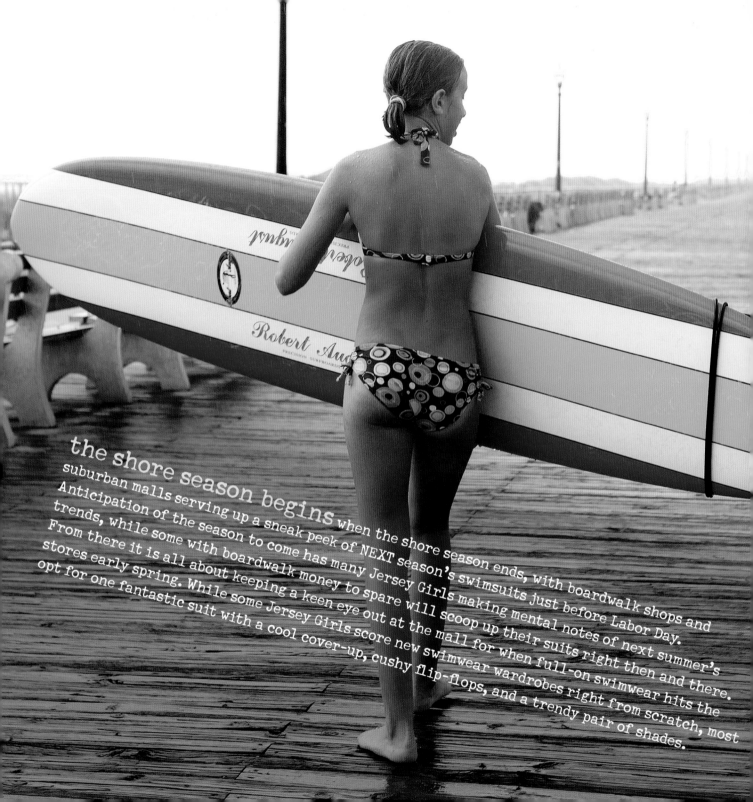

the shore season begins when the shore season ends, with boardwalk shops and suburban malls serving up a sneak peek of NEXT season's swimsuits just before Labor Day. Anticipation of the season to come has many Jersey Girls making mental notes of next summer's trends, while some with boardwalk money to spare will scoop up their suits right then and there. From there it is all about keeping a keen eye out at the mall for when full-on swimwear hits the stores early spring. While some Jersey Girls score new swimwear wardrobes right from scratch, most opt for one fantastic suit with a cool cover-up, cushy flip-flops, and a trendy pair of shades.

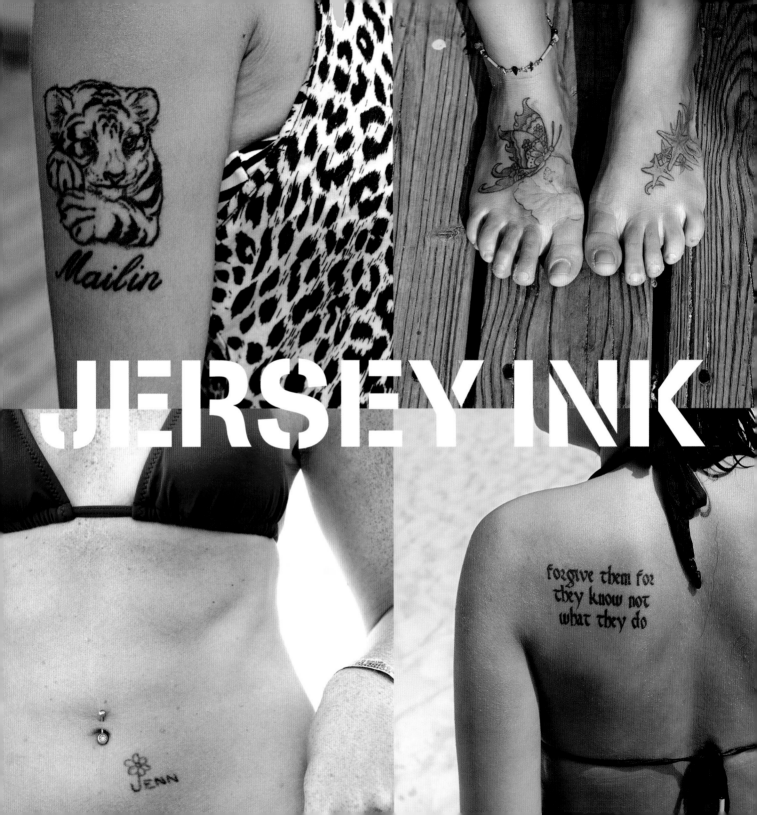

JERSEY INK

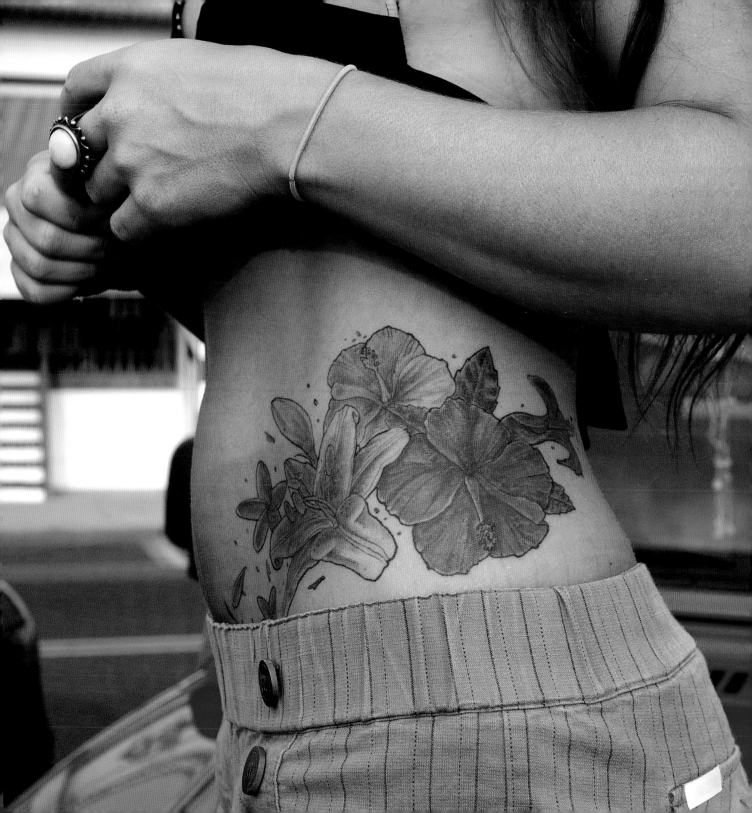

i met my boyfriend on the boardwalk that summer

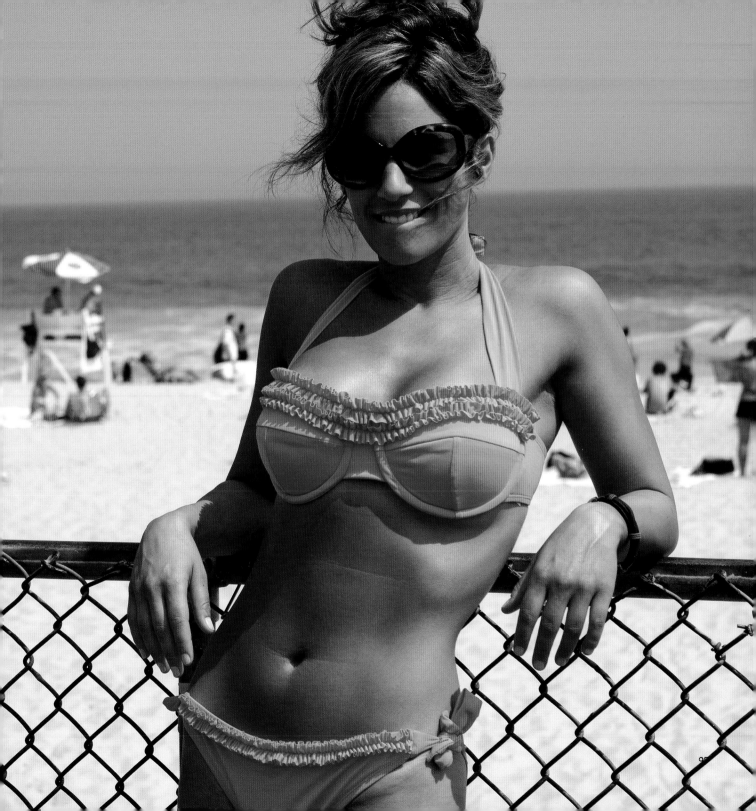

THE BOARDWALK WAS
WHERE ALL OF NJ
CAME TOGETHER
WHERE NJ FOR
BETTER OR WORSE,
MET ITSELF

JUNOT DÎAZ, PULITZER PRIZE
WINNER / NJ NATIVE

SPLASH °F RED.NET

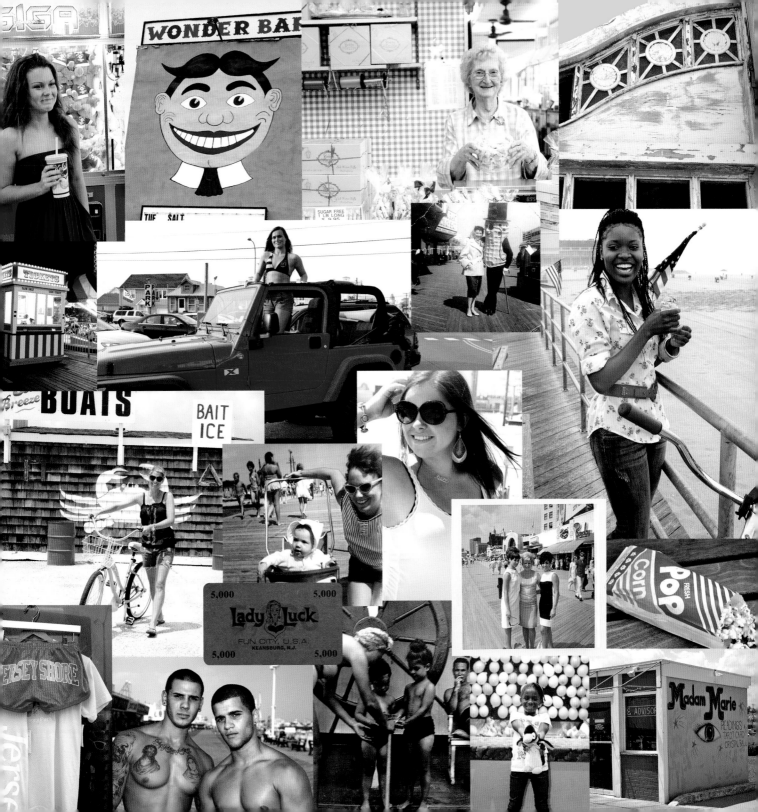

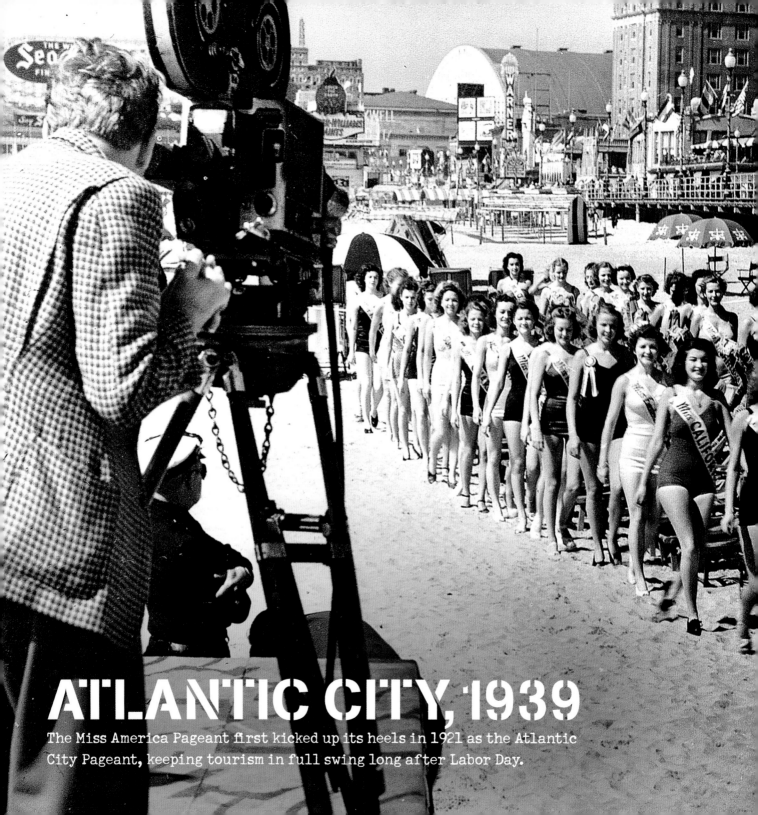

ATLANTIC CITY, 1939

The Miss America Pageant first kicked up its heels in 1921 as the Atlantic City Pageant, keeping tourism in full swing long after Labor Day.

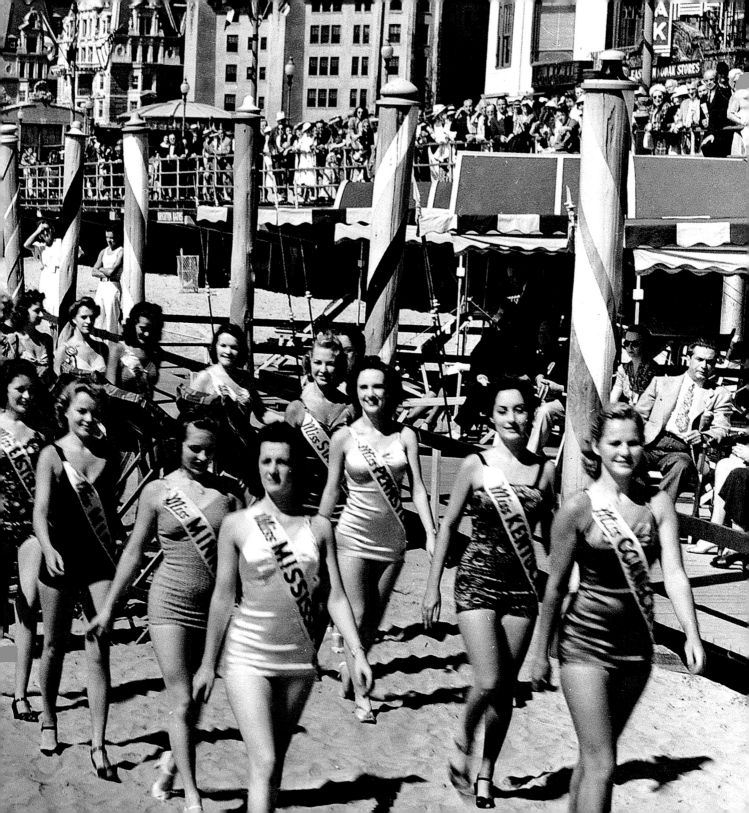

Shore house rental and Ocean Avenue motel assessing also begin the season as autumn comes to

call. Who's in and who's out, friend-wise, leads to securing the place with a contract

and a deposit. With a place-to-stay commitment, daydreams of next summer's fun begin.

everybody go hotel, motel, holiday inn

jersey girls grow up thinking **every** *girl has a boardwalk in her backyard*

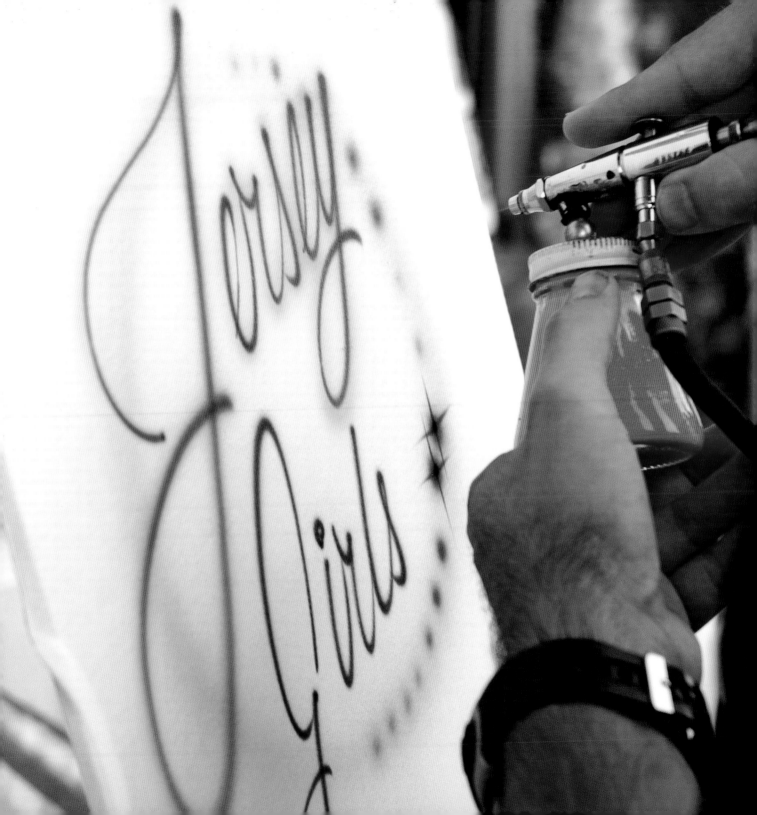

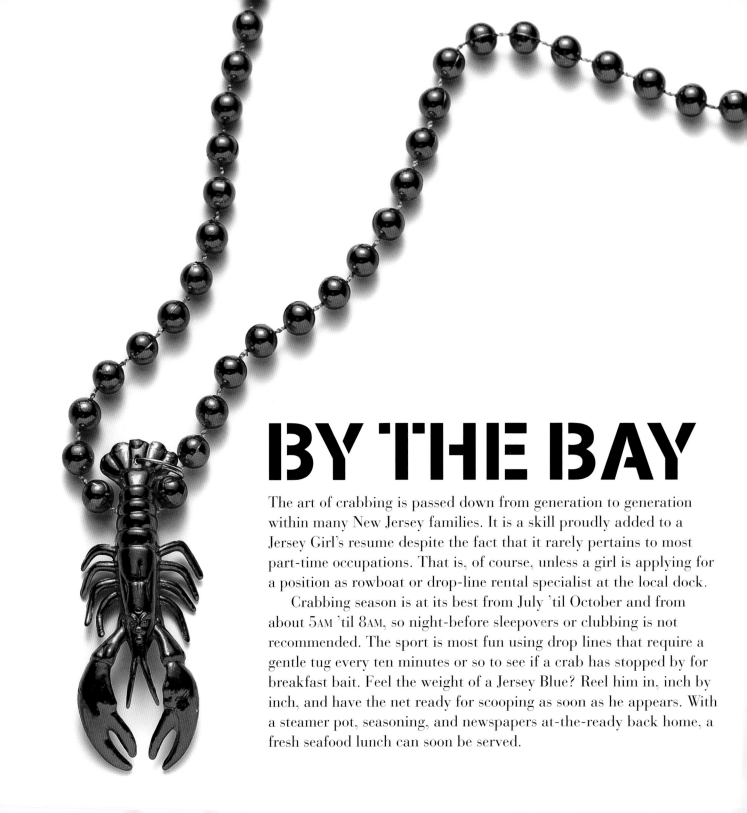

BY THE BAY

The art of crabbing is passed down from generation to generation within many New Jersey families. It is a skill proudly added to a Jersey Girl's resume despite the fact that it rarely pertains to most part-time occupations. That is, of course, unless a girl is applying for a position as rowboat or drop-line rental specialist at the local dock.

Crabbing season is at its best from July 'til October and from about 5AM 'til 8AM, so night-before sleepovers or clubbing is not recommended. The sport is most fun using drop lines that require a gentle tug every ten minutes or so to see if a crab has stopped by for breakfast bait. Feel the weight of a Jersey Blue? Reel him in, inch by inch, and have the net ready for scooping as soon as he appears. With a steamer pot, seasoning, and newspapers at-the-ready back home, a fresh seafood lunch can soon be served.

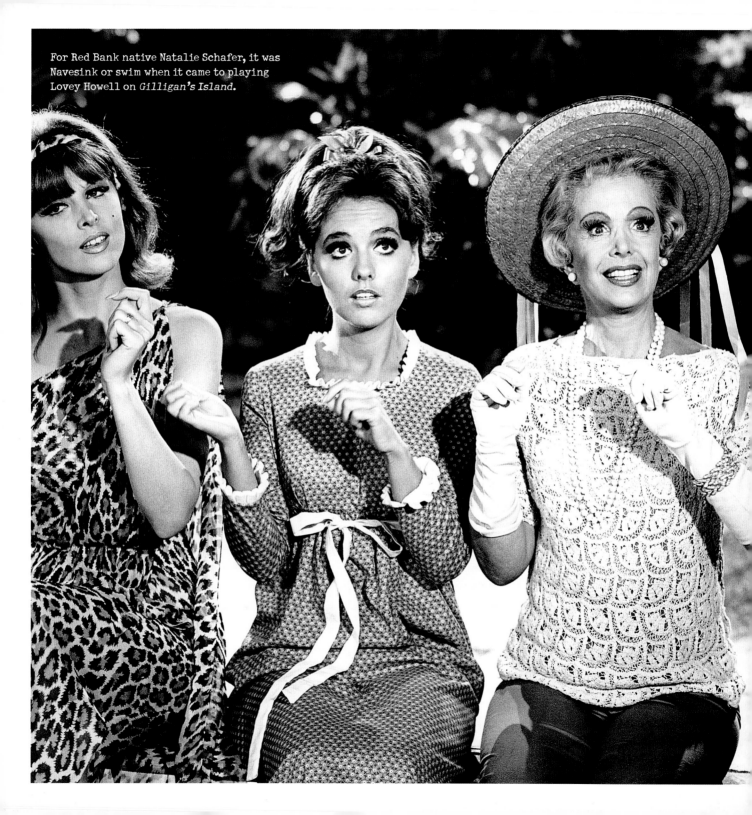

For Red Bank native Natalie Schafer, it was Navesink or swim when it came to playing Lovey Howell on *Gilligan's Island*.

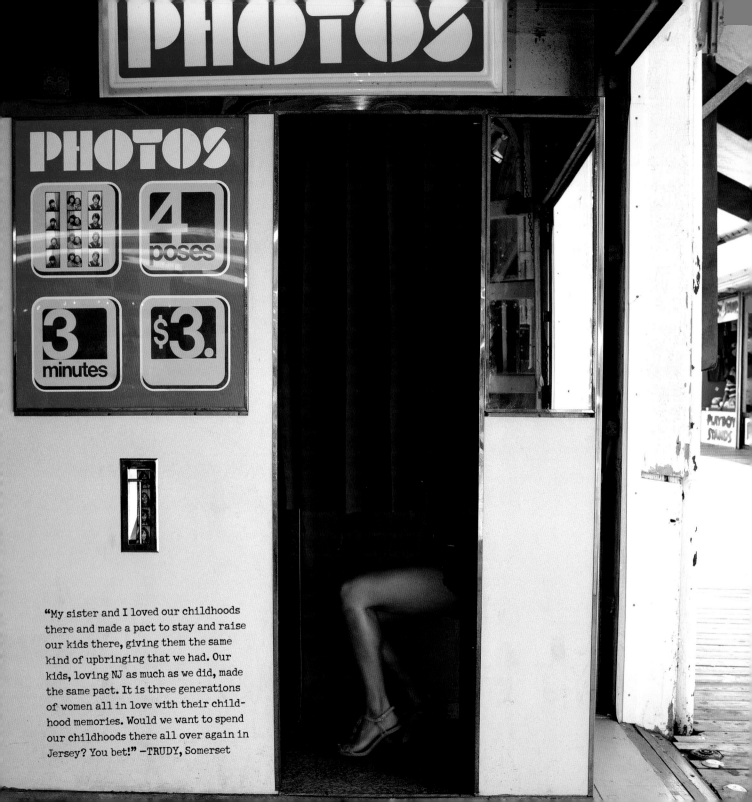

PHOTOS

PHOTOS

4 poses

3 minutes

$3.

"My sister and I loved our childhoods there and made a pact to stay and raise our kids there, giving them the same kind of upbringing that we had. Our kids, loving NJ as much as we did, made the same pact. It is three generations of women all in love with their childhood memories. Would we want to spend our childhoods there all over again in Jersey? You bet!" —TRUDY, Somerset

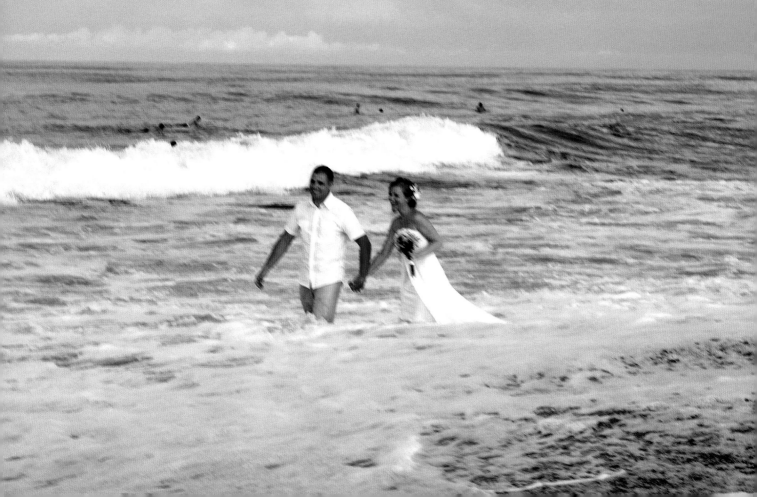

I LOVE YOU
MORE THAN THE
DEEP BLUE SEA

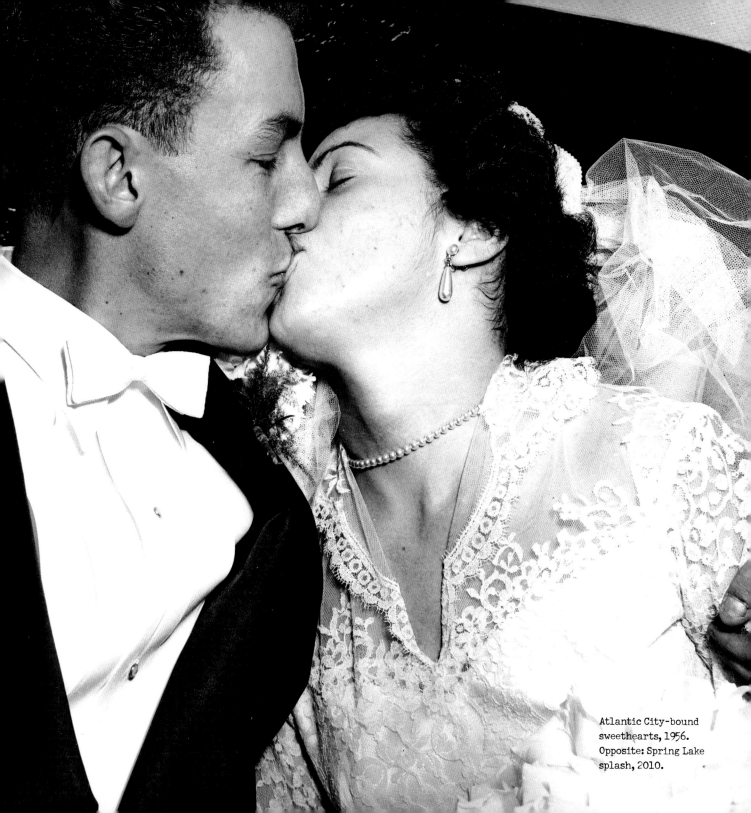

Atlantic City-bound
sweethearts, 1956.
Opposite: Spring Lake
splash, 2010.

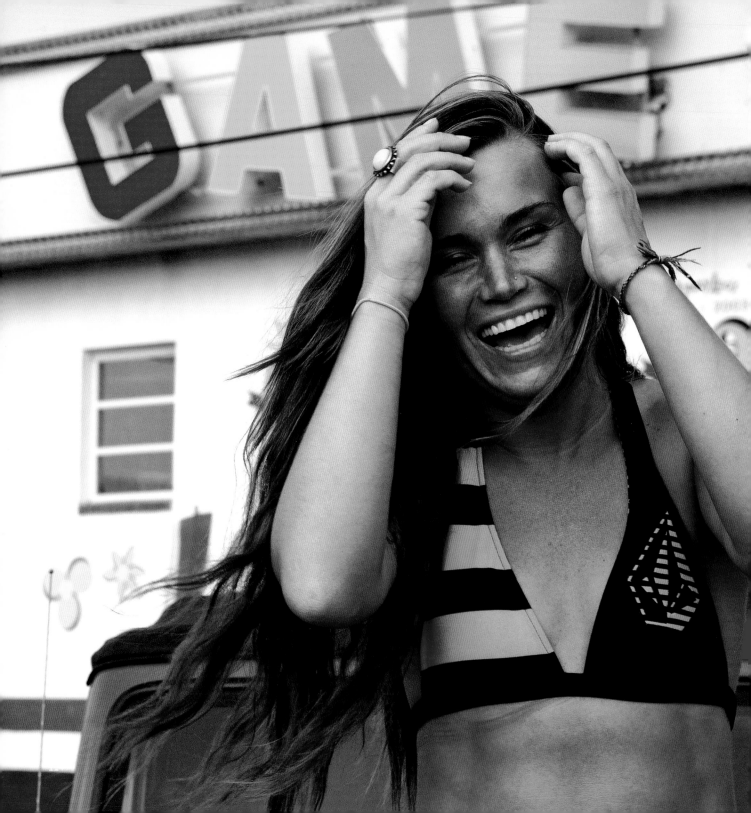

game GIRL

There's no doubt that every Garden State girl's got game. Down the shore that game can be admired front and center at the prize-filled booths that decorate and dot the boardwalks, and among the twinkling and "bing-bing-bing" of the game-filled arcades.

A Jersey Girl is motivated by the promise of "winner's choice," which means if she wins she can choose her own prize, thank-you-very-much. These games require Lady Luck be present as quarters are placed on an ace of spades or blue "Pop" for a spin of the wheel that just might land on one of them. Until that wheel is done spinning, any prize seems a possibility, from an electric guitar or neon JERSEY GIRL lamp, to a souvenir Bon Jovi pillow.

Games that require a studied skill, like the squirting gun game that pops a balloon, or a mallet smashing game that gets rubber frogs to jump onto lily pads, can take years of practice, though most Jersey Girls are pretty much born ready to take on whatever the boardwalk game gods can cook up.

Inside the arcades, where both skill AND luck come into play (and lots of allowance and babysitting money), Jersey Girls settle in on games that kick out colorful prize tickets that can be traded in for a handful of meticulously chosen "smalls" or tiny plastic treasures and sweets. Shore girls with patience tuck away their tickets all summer long, saving up for one big dusty prize that can be proudly carried around the boardwalk to show off one's game-mastering prowess, in a virtual runway show and tell. Even in extreme summertime heat, there is something simply fabulous about the back-and-forth lugging around of a five-foot plush parakeet or poodle.

Other arcade skills require getting layers of quarters to teeter and spill over an edge on their way to spewing tickets, and crane games that grab and drop everything from taffy and gum to electronics.

When it comes to Skee Ball, spectators step aside to behold a Jersey Girl's skill at the side-roll-and-dunk technique of the heavy wooden balls, mastered with years of practice. Tickets "ding-ding-ding" their way out of the machine after every roll of the ball, twisting and curling into what becomes a temporary Skee Ball trophy, of sorts.

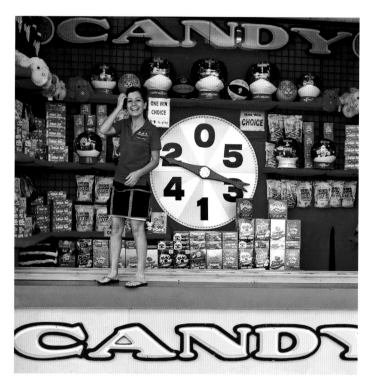

most jersey girls are pretty much born ready to tak

on whatever the boardwalk game gods can cook up.

117

step right up and try your luck for just a buck

118

From Keansburg's Kiddyland to Wildwood's wild rides, a Jersey Girl knows from knee-high how to navigate boardwalk amusement rides with the ease and skill of an outdoor adventurer. She takes pride in playing captain on her own candy-colored speedboat through the neon blue waters of the river swell below (can you hear her bell ringing?!), and goes straight away for an all-out hands-held-high spin on the Dragon Coaster and Whip.

The season her ponytail skims the clown's 42-inch-high hand she becomes a bittersweet graduate of kiddy rides, off and running to the senior high of all attractions, the Himalaya, the Swings, and the Tornado. Even the Haunted Mansion awaits.

At night, the pretty little cities of pier lights glow and sparkle across the ocean like a skyline of fireworks, seemingly placed there just for her.

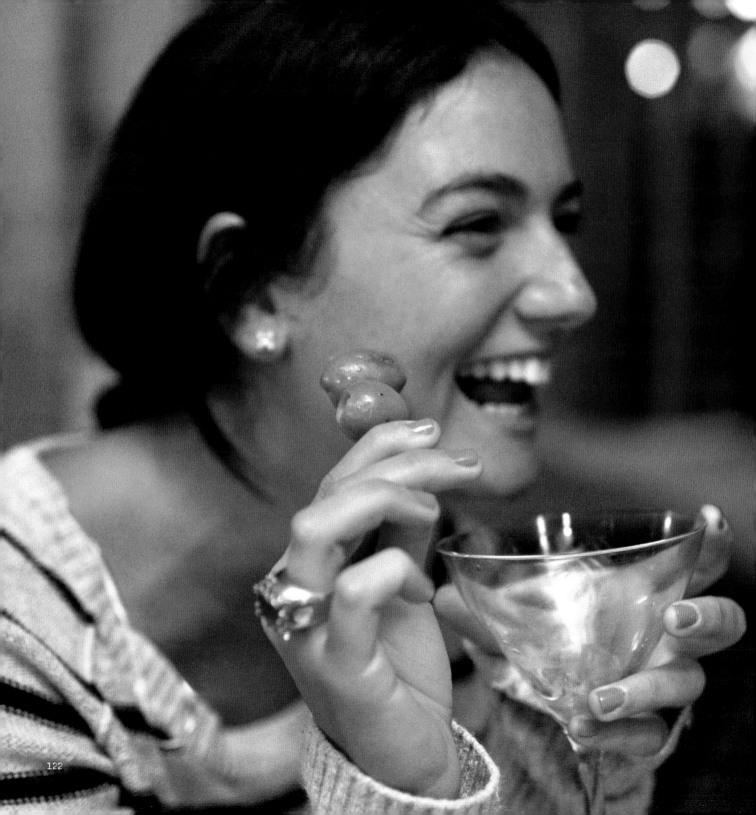

CLUBBING AT THE SHORE: 2 SCENARIOS

1: A GIRL AND HER GIRLS CAN MAKE A NIGHT OF IT AT AN INLAND CLUB, ARRIVING JUST AFTER GRABBING A BITE, SPENDING THE EVENING DANCING, DRINKING, AND FLIRTING (BUT MOSTLY DANCING). CLUB OF CHOICE IS DETERMINED BY REGULARITY OF "CUTE GUY QUOTIENT," A DANCE FLOOR RIPE FOR SHOWING OFF A TAN, AND, PERHAPS, THE APPEARANCE OF A FAVORITE COVER BAND. THIS IS CONSIDERED THE MORE SOPHISTICATED CLUB-GOING ROUTE.

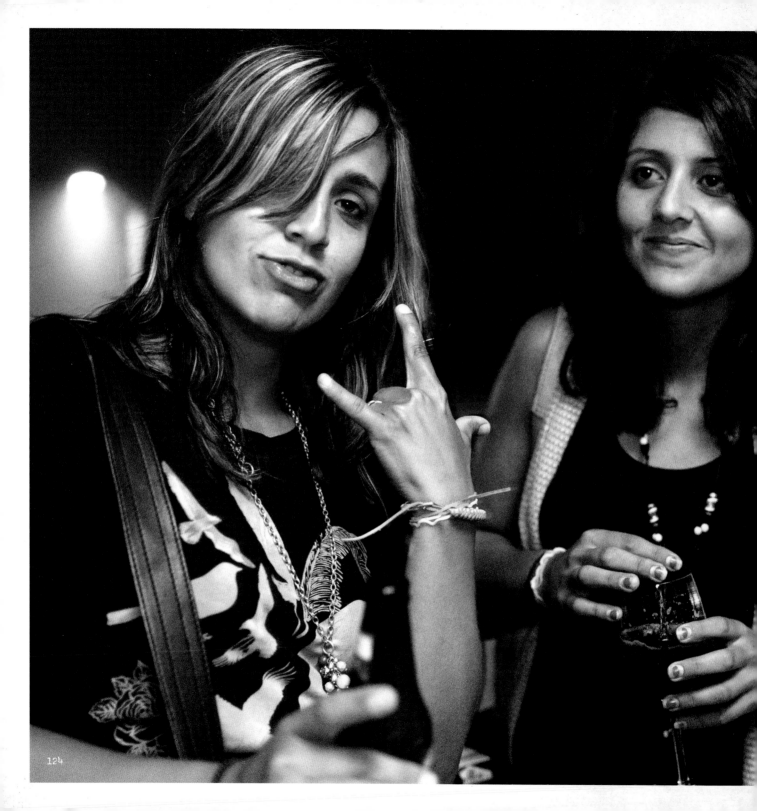

2: SCENARIO DEUX HAS GIRLS HITTING THE BOARDWALK FIRST,

CARRYING CLUB SHOES IN HAND, RIDING THE RIDES, EATING

COTTON CANDY, DOING A LITTLE SHOWING OFF BEFORE SHOWING

UP TOGETHER INSIDE A JUST-OFF-THE-BOARDWALK CLUB. WHICH

CLUB TO CRASH IS DETERMINED BY PROXIMITY TO WHERE THE CAR

HAS BEEN PARKED OR WHERE THE SHORE HOUSE IS SITUATED, OR,

SIMPLY, BY FOLLOWING A CUTE BOY INSIDE.

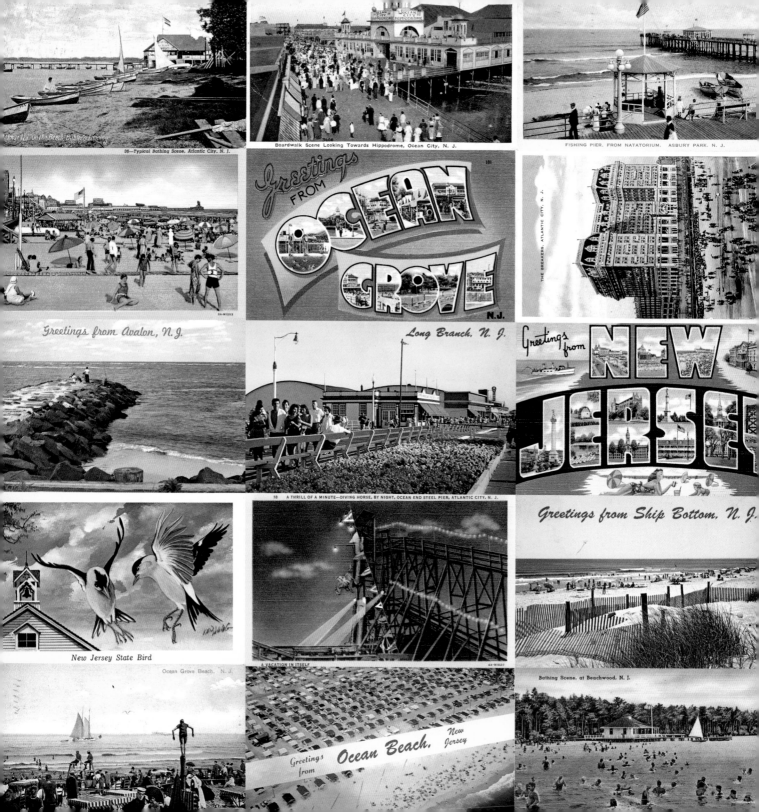

Ocean N.J. On the Beach, Budlee's Landing

36—Typical Bathing Scene, Atlantic City, N. J.

Boardwalk Scene Looking Towards Hippodrome, Ocean City, N. J.

FISHING PIER, FROM NATATORIUM. ASBURY PARK. N. J.

Greetings FROM OCEAN GROVE N.J.

THE BREAKERS, ATLANTIC CITY, N. J.

Greetings from Avalon, N. J.

Long Branch. N. J.

Greetings from NEW JERSEY

18 A THRILL OF A MINUTE—DIVING HORSE, BY NIGHT, OCEAN END STEEL PIER, ATLANTIC CITY, N. J.

Greetings from Ship Bottom. N. J.

New Jersey State Bird

Ocean Grove Beach. N. J.

A VACATION IN ITSELF

Bathing Scene, at Beachwood, N. J.

Greetings from Ocean Beach, New Jersey

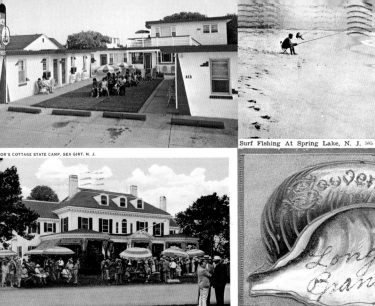

OR'S COTTAGE STATE CAMP, SEA GIRT, N. J.

Surf Fishing At Spring Lake, N. J. 505

Souvenir Long Branch

Beach & Boardwalk and Ocean Front Cottages at Cool Cape May, N. J.

Greetings from MANASQUAN INLET, N. J.

Waiting for my Pals here at the Beach, Avon By-The-Sea, N. J.

New Jersey State Flower

Greetings from KEANSBURG N. J.

303. SEVILLE HOTEL, WILDWOOD BY-THE-SEA, N. J.

Greetings from Ortley Beach, N. J.

Greetings from Keansburg, N. J.

General View Beach and Ocean Front from Pier, Ocean City, N. J.

1559

BOBBI BROWN

MAKE UP MASTER, AUTHOR · MONTCLAIR BY WAY OF BAY HEAD, GARDEN STATE PARKWAY EXIT 151

WHEN DID YOU OFFICIALLY BECOME A JERSEY GIRL? I moved here in 1989, so I consider myself a born-again Jersey Girl.

FAVORITE SHORE HANGOUTS? I like the beach in Bay Head, and love the Bay Head shop The Bee. My favorite down-the-shore eats are Surf Taco and Red's.

BEST WAY TO GO FROM BEACH GLOW TO NIGHT OUT GLAM? Apply a cream eye shadow that can be applied quickly and easily, stays on, and doesn't crease. Wear a no smudge or waterproof long-wear mascara as it has multiple benefits of lengthening lashes and staying put. Next, apply a bronzer that glides on evenly and gives skin a natural-looking glow. Apply to where the sun naturally hits your face on your forehead, top of your nose and cheekbones. Lastly, lip gloss is the easiest way to polish off a look. Choose a bright color for summer that will compliment your tan. Finally, I always tell women to carry blotting papers to absorb any excess oil that may build up due to the heat.

FAVORITE BOARDWALK? I like Point Pleasant, especially love getting oysters on the boardwalk.

FAVORITE DINER? Raymond's. It is upscale but has a diner feel. I love to get the veggie chili there.

CAN YOU TURN ANYONE INTO A FABULOUS JERSEY GIRL? It's like your love of Bruce Springsteen, you either have it or you don't.

HAS JERSEY GIRL STYLE EVER INFLUENCED YOUR MAKEUP LINE? A Jersey Boy named Yogi Berra influenced my Yogi Bare lip balm! New Jersey in general has influenced a few other collections as well. Princeton University inspired a collection called Ivy League and Bay Head inspired my "Beach" fragrance.

GOT A FAVORITE FAMOUS JERSEY GIRL OR TWO? Queen Latifah, Meryl Streep, and Susan Sarandon. They are all strong, confident women who have their own beauty styles. They are pretty and they are powerful.

BEST JERSEY GIRL TRAIT? They are comfortable in their own skin.

FAVORITE MALL? Short Hills.

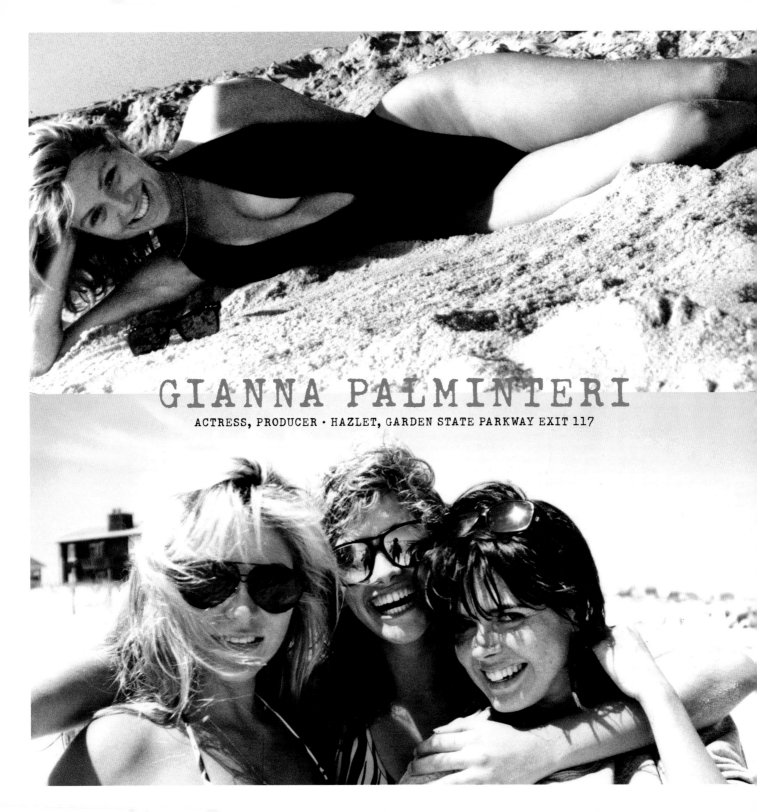

GIANNA PALMINTERI

ACTRESS, PRODUCER · HAZLET, GARDEN STATE PARKWAY EXIT 117

HIGH SCHOOL DRAMA? I went to St. John Vianney in Holmdel, where I was a featured twirler and majorette for the Lancers. Though my goal was to become a doctor, I loved performing with the drama department there and was drawn to the stage.

HOW WERE YOU DISCOVERED? I became NJ's Monmouth County Junior Miss while I was in high school, Miss Jersey Shore, and first runner up to Miss NJ while I was at Villanova University. By then my dream of becoming a doctor was overshadowed by my need to be in front of the camera. This led me to become the first host of the Travel Channel's *World of Travel*. In college, I rented a studio apartment in NYC with some fellow models and we spent weekends there. After Villanova, I studied theater in NYC at the Meisner Studios and the Esper Conservatory.

GROWING UP JERSEY GIRL? My parents are from Italy and came to the states as teens to study. I spoke Italian and English at home. Though I had a very all-American look, I felt completely out of place because I was raised in a European fashion. I wasn't allowed to sleep over my friends' houses and I was kept in a very traditional female role. I knew there was a life outside of NJ—that's what makes a Jersey Girl special. No matter where you go, you can fit right in and be anything you want to be.

GARDEN STATE BESTS? NJ has the best horse-riding country, the best beaches, the best orchards, and wonderful farms. We lived in Colts Neck—that's where my son, Dante, first learned to ride. The Colts Neck Stables are incredible.

HOW DID YOU MEET CHAZZ? We met in Beverly Hills at St. Charles church. The following week we met up at a big club called Bar One in Beverly Hills. I took him home to Hazlet at Christmas a few months later to meet my parents and my grandfather from Italy. They are originally from Rome, Salerno, and Avellino. It was the Bronx Boy meets the Jersey Girl. Chazz was kind of shocked and comfortable at the same time. We felt comfortable with each other—probably because our backgrounds are very similar. We've been married for nineteen years and have two children, Dante and Gabriella.

FAVORITE DINER DISH? An omelet—spinach with light feta please!

DID YOU GET RECORDS AT JACK'S IN RED BANK? I did, actually! My first album was the Police.

FAVORITE JERSEY CLUB? I went to the Stone Pony for the music and dancing. My son Dante is going to play the Pony with his band—stay tuned for Kaymus!

WHAT DO YOU MISS WHEN YOU ARE AWAY? The beaches—there is nothing like the sandbars off the shore of Long Beach Island. I'd also have to say Stewart's or the Red Bank Diner—I love the Red Bank Riverfront. It's so quaint, a real draw for the state.

FAVORITE JERSEY BAND? Bruce and Jon. And David Bryan of Bon Jovi, who won a Tony for *Memphis*!

WHAT WAS IT LIKE HAVING NYC IN YOUR BACKYARD? I didn't realize the Hudson was a dividing line. It was just a sweet pond I used to cross. There was "The City" and I lived at "The Beach."

FAVORITE JERSEY GIRLS? Dorothea Hurley, Brooke Shields, Patti Scialfa, Emme Aronson, and my right hand girl, Staci Gilchrist.

BEST PORTRAYAL OF A JG IN A MOVIE? All the Kevin Smith movies, but especially Liv Tyler in *Jersey Girl* with Ben Affleck.

FAVORITE JG MEMORIES? All the actors from my agency used to come home with me to Sunday dinner. My parents never knew how many young, hungry actors were coming to dinner. Julia Roberts, my best friend at the time, used to come along to my Long Beach Island house. We'd trek down every weekend to LBI.

REFLECTIONS ON JERSEY MOMS? I raised my son at our farm in Colts Neck until he was four. I have to say that of all the mothers I have met, Jersey moms are the best. And no matter where I am, I can always call my NJ girlfriends and feel at home. We also have a love for each other's children, which to me is special. The most sincere friendships are with my girls from NJ.

JONATHAN ADLER

DESIGNER · BRIDGETON/CUMBERLAND COUNTY, NJ TURNPIKE EXIT 2

YOU'RE A SELF-PROCLAIMED JERSEY GIRL AND PROUD OF IT, HUH? What's not to be proud of? I grew up in a remote and rural part of New Jersey and it was great. Door never locked, dogs running around, riding my bike everywhere, exploring the woods. I grew up in the '70s and '80s and people weren't terrified of everything and my parents paid no attention to me. Fab!

WHAT HIGH SCHOOL DID YOU GO TO? I went to a high school in Wilmington, Delaware called Tatnall.

FAVORITE TEACHER? Mrs. Mason, my pottery teacher. She was the only one who liked me!

WHAT MAKES YOU JERSEY? I think that if you come from New Jersey you can't be pretentious. You're simply not allowed. So I hope that what makes me New Jersey is that I'm not too fancy.

MEMORABLE GET-UPS? Unfortunately, I was pretty preppy in high school, so no fantastic embarrassments.

DID YOU GO TO THE PROM? Yes, and THAT was a bit of a fantastic embarrassment.

SHOUT OUT TO MOM: She grew up in South Orange, went to Wellesley, worked at *Vogue*, then married my dad and he dragged her to his hometown, a farm town, and she made the best of it. She is hilarious and she never, ever, ever says anything banal.

FAVORITE MALL? Cumberland County Mall.

BEST BEACH? Wildwood Crest, hands down.

FONDEST MEMORY? Jersey tomatoes.

WHAT DO YOU MISS? I miss a time when nobody had even conceived of the phrase "Lifestyle Brand." Times were simpler.

WHAT STYLE QUIRK DO YOU MOST ADMIRE IN A JERSEY GIRL? Jersey Girls totally go for it. Unpretentious!

WHAT DEFINES A JERSEY GIRL MOST? A sense of fun.

WHAT DID YOU TAKE ALONG WITH YOU FROM YOUR JERSEY UPBRINGING? Humility.

Pool boy
Liberace with
Jonathan.

Lunchtime with Beth.
Tenafly, 1977.

EATS
SERVING UP THE DISH

QUINTESSENTIAL QUICKIE: Roadside joints with local landmark status serve up classic charbroiled favorites.

While a ripe Jersey tomato can certainly be considered the state's most officially unofficial fare, Jersey Girls are lucky enough to have many other down-home favorites to enjoy. A Jersey Girl's town will undoubtedly boast the best, from a perfect slice to classic eggs-on-a-hard-roll-to-go, and a fancy night out often calls for the family-run ristorante just around the corner.

Jersey Girls can go international with global fare at every turn, and are spoiled by the Garden State's homegrown crops of sweet corn, tomatoes, cranberries, and apples.

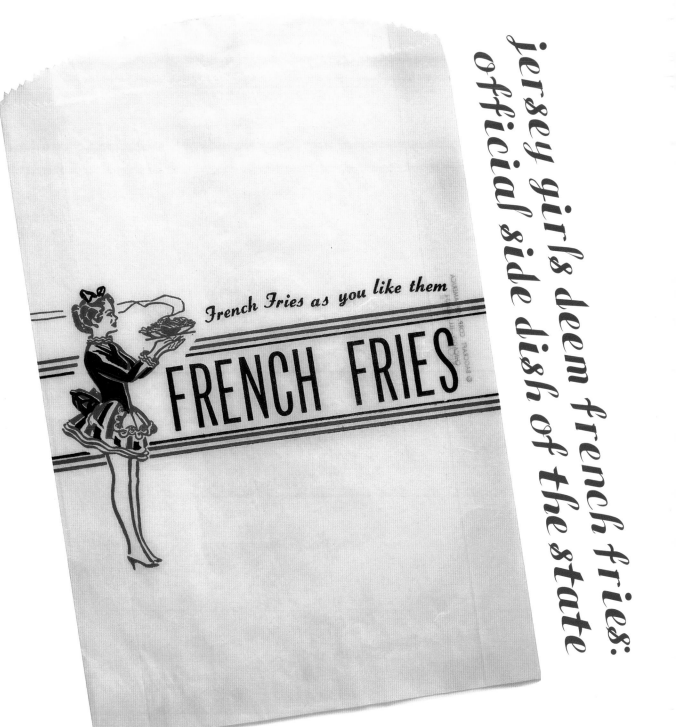

French Fries as you like them

FRENCH FRIES

jersey girls deem french fries:
official side dish of the state

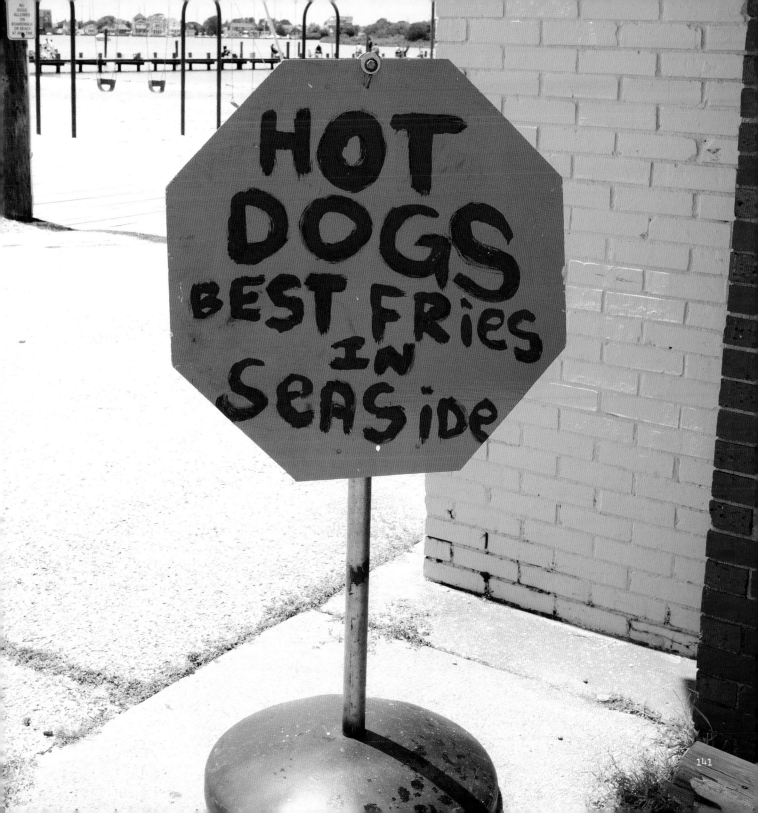

LAURA PLIMPTON & MARTHA STEWART'S JERSEY GIRL CANNED TOMATOES

(as passed down from mother, Martha Koystra)

"Our mom, Martha Koystra, made several batches of canned tomatoes every summer from all of the fabulous Big Boy and Better Boy tomatoes that my father grew in abundance. My dad was an excellent gardener and he especially took great pride in his amazing tomato crop. He planted at least a hundred plants each season and because of the great Jersey loam, his plants bore tomatoes weighing two pounds each, at least. My mother served tomatoes all summer long and canned many jars to use during the rest of the year. One slice of a tomato that size made a delicious sandwich on white bread, sliced red onion, and bread-and-butter pickles, which my mom also put up each year." —Laura Plimpton

INGREDIENTS:
(Makes 6 quarts)
18 lbs. ripe tomatoes
2 tbsp. coarse salt
12 fresh basil leaves

1. Prepare an ice-water bath; set aside. Bring a large stockpot of water to a boil. Score an X in the bottom of each tomato. Boil tomatoes in batches until skins begin to split, 1 to 2 minutes. Transfer to the ice-water bath; let cool slightly. Peel, core, and halve tomatoes. Working over a sieve, set in a bowl; remove seeds. Discard seeds and reserve juice.

2. Add lemon juice, if using (see note at far right), 1 tsp. salt, and 2 basil leaves to each of 6 hot, sterilized 1-quart jars. Fill jars with tomatoes. Cut sides down, compressing with a rubber spatula to remove air bubbles. Add reserved juice, leaving 1/2-inch space in each jar's neck. Wipe rims of jars with a clean, damp cloth; cover tightly with sterilized lids and screw tops.

3. Transfer jars, using tongs or jar clamp, to the rack of a large canning pot filled with hot water; cover with water by 2 inches. (Jars should be spaced 1-inch apart and should not touch sides of pot.)

4. Cover; bring to a boil. Process jars in gently boiling water for 45 minutes. Transfer to a wire rack; let cool 24 hours. Press down on each lid. If lid pops back, it is not sealed; refrigerate unsealed jars immediately, and use within 2 weeks. Sealed jars can be stored in a cool, dark place up to a year.

5. Be sure to sterilize jars in boiling water for fifteen minutes. Use new lids, and sterilize them according to manufacturer's instructions.

The USDA recommends adding two tbsp. lemon juice to each quart of tomatoes to increase the acidity and to help prevent spoilage.

i'm jersey fresh

MEATBALLS
CHEESE FRIES
HOT DOGS

CHEESE STEAK FUNNEL CAKE FRESH

FUNNEL CAKE

FRIED
Chocolate Sandwich Cookies
OREO
America's Favorite Cookie
6 for $5.00

LEMONADE

OREO FUNNEL CAKE

DASANI

DASANI *Coca-Cola* DASANI *Coca-Cola* DASANI
FRESH - CUT
FRENCH - FRIES

"Aside from the boardwalk (food, smells, people) and the ocean, New Jersey will always remind me of being with family. It was the time we all got together." —Nicole, Hollywood by way of Wildwood

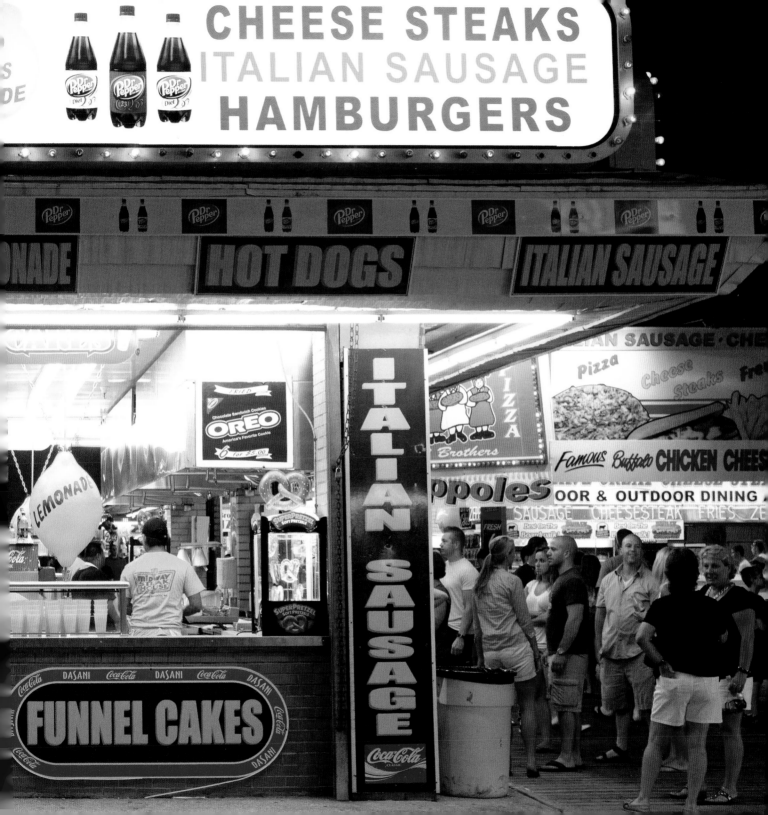

nice catch

From a catch-'em-and-clean-'em take on fishing and crabbing to a girl who lives for lobster (red and ready, thank you very much!), there is no dockside doubt that a Jersey Girl takes pride in her seafood savvy.

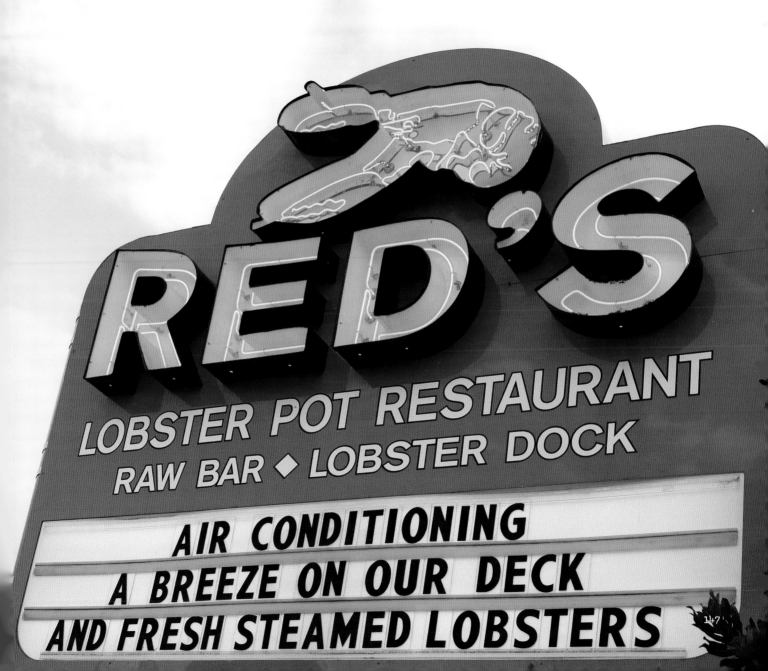

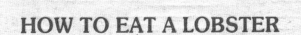

HOW TO EAT A LOBSTER

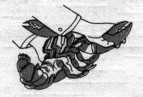

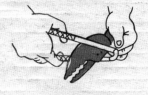

1. TWIST OFF THE CLAWS

2. CRACK CLAW WITH NUTCRACKER

3. SEPARATE THE TAILPIECE FROM BODY BY ARCHING THE BACK 'TIL IT CRACKS

4. BEND BACK AND BREAK FLIPPERS OFF TAILPIECE

5. INSERT FORK WHERE THE FLIPPERS BROKE OFF & PUSH

6. UNHINGE THE BACK - THE "TOMALLEY" OR LIVER, A DELICACY TO MANY LOBSTER EATERS, WILL TURN GREEN WHEN BOILED

7. OPEN THE BODY CRACK IT SIDEWAYS THERE IS GOOD MEAT IN THIS SECTION TOO

8. THE SMALL CLAWS ARE EXCELLENT EATING - SUCK THE MEAT OUT

BOOTHS & COUNTERS

When doing the diner, ordering breakfast 24/7 is a Jersey Girl given. Ketchup is key for scrambled eggs, while bacon and hash browns make good company. Pie slices plucked from `spinning displays` and mini boxed cereal with milk à la carte are Jersey diner delicacies, while the `Happy Waitress Special` keeps sandwich girls smiling.

ABCDEFGHJK
123456789 10

BUTTERED HARD ROLL CHEESE FRIES BAKED POTATO DUTCH
TOAST SCRAMBLED EGGS WITH KETCHUP GRILLED CHEESE WIT
PIZZA TUNA MELT LEMON SHAKE-UP HAPPY WAITRESS SPECIA
APPLE CIDER DONUTS SCRAPPLE SALISBURY STEAK STEAMERS
SALT WATER TAFFY STEAMED LOBSTER BLUEBERRY PANCAKE

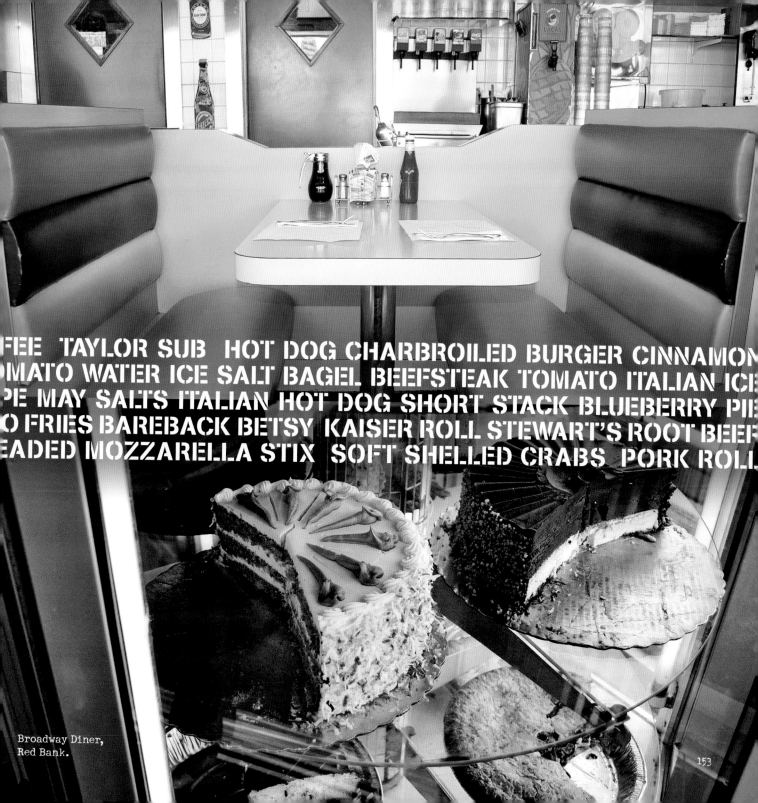

FEE TAYLOR SUB HOT DOG CHARBROILED BURGER CINNAMON
OMATO WATER ICE SALT BAGEL BEEFSTEAK TOMATO ITALIAN ICE
PE MAY SALTS ITALIAN HOT DOG SHORT STACK BLUEBERRY PIE
O FRIES BAREBACK BETSY KAISER ROLL STEWART'S ROOT BEER
EADED MOZZARELLA STIX SOFT SHELLED CRABS PORK ROLL

Broadway Diner,
Red Bank.

"I couldn't wait to take my daughter back to my hometown, Elmwood Park, where Pizza Town is still serving the best zeppoles and River View East still serves up French fries with gravy, a local delicacy!" –Dawn, Maplewood

"The Tavern restaurant was a Newark institution. My father took us every Sunday night for an early dinner. A full meal and dessert was about $3.50. Those delicious meals made me the foodie that I am today!" –Barbara, Short Hills

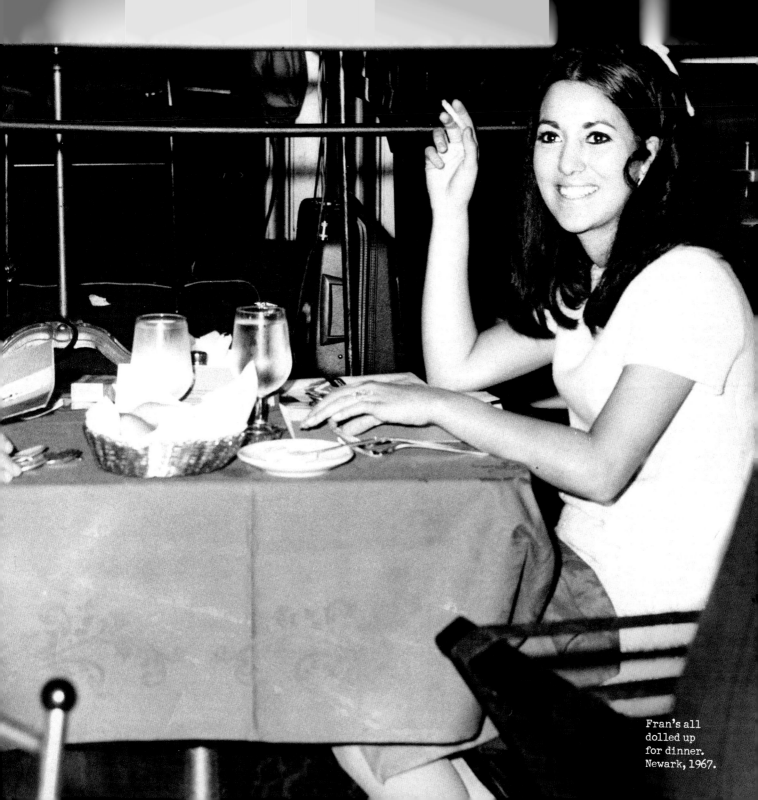

Fran's all
dolled up
for dinner.
Newark, 1967.

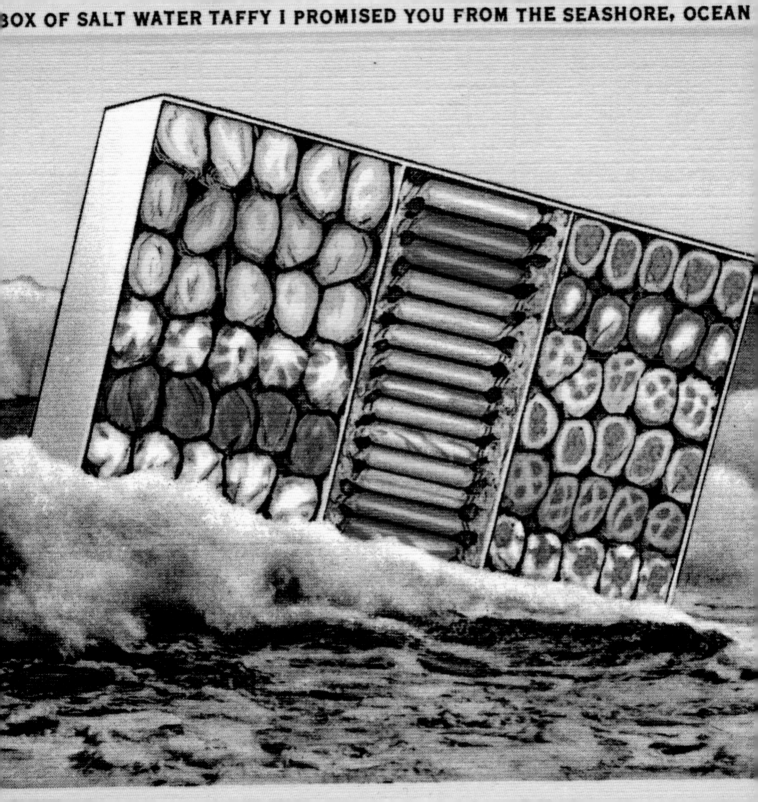

JERSEY GIRLS ARE SWEET ON STATESIDE TREATS BORN AT THE BOARDWALK, LIKE SALT WATER TAFFY, CANDIED APPLES, ITALIAN ICE, LEMON SHAKE-UPS, AND FROZEN CUSTARD CONES. OLD-FASHIONED, FAMILY-RUN CANDY SHOPPES SPOIL A GIRL FROM HER VERY FIRST VISIT TO THE SHORE, BY OFFERING UP GOODIES BETTER THAN ANY BOARDWALK PRIZE

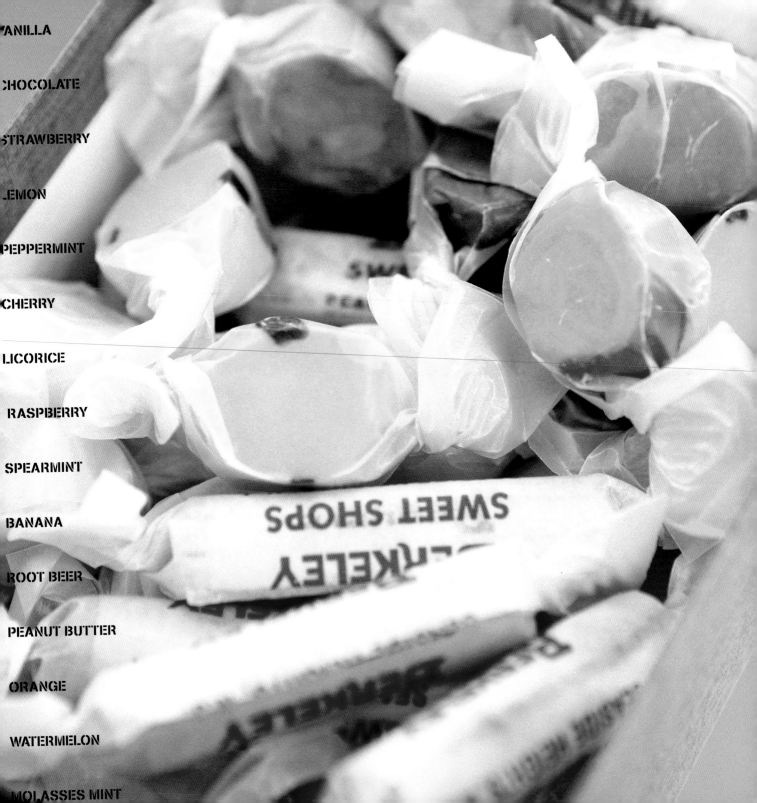

VANILLA

CHOCOLATE

STRAWBERRY

LEMON

PEPPERMINT

CHERRY

LICORICE

RASPBERRY

SPEARMINT

BANANA

ROOT BEER

PEANUT BUTTER

ORANGE

WATERMELON

MOLASSES MINT

Berkeley
Sweet Shops

SALT WATER TAFFY

GOING TWO PIECES:
Beach-bound candy
girls get their fix
from old-school
sweet shops.

LAURA SAN GIACOMO

ACTRESS · DENVILLE, GARDEN STATE PARKWAY EXIT 142B

When I met Karen Duffy for the first time recently at a wedding in Italy, we knew it was a Jersey Girl moment. But really, don't all roads lead back to Jersey?

MEMORIES OF GROWING UP "JERSEY"? I was born in West Orange and we moved to Denville when I was in elementary school. At the time, Denville was a little summer lake community. It was pretty remote. Our mailing address was "Rural Delivery #1," and we were a one stop light town. I still go back and visit some of the same businesses that are still there. Much of it is still the same.

I remember playing all around, in the brook, the wild areas, the woods all around where a paper mill used to be. My father was a volunteer fire fighter there and every night the six o'clock whistle would blow and that's when we had to head home. There was a beautiful swimming hole with old trees hanging over it, and a wood dock. You could barely see this swimming hole from the road. It was very secluded, a very special place.

New Jersey has so many places like that, it's very different from the perception of being all highways. The Pine Barrens are still untouched, and I loved visiting the Great Swamp National Wildlife Refuge on school trips—so beautiful.

In high school I started doing plays and studied drama with two great teachers, Renee and James Lavin. I loved the field trips to see different productions in the area and in New York City. I remember seeing Julie Harris—one of my acting heroes—perform in *The Belle of Amherst* at the Paper Mill Playhouse.

THOUGHTS ON JERSEY GIRL MOMS? As a Jersey Girl I felt empowered by a combination of growing up in a supportive family and by seeing empowered women all around me. I was surrounded by strong women like my mom and grandmother, women who don't take a lot of guff. I remember being in high school drama class and having to make and pay for our own costumes for shows. My mother marched right into a board meeting to find out why this was since the football players never had to pay for their uniforms. She stuck up for us, because as a Jersey mom you are really "in there" up to your elbows. There is a real dedication to your kids and your family. For me, I'm not afraid to stand up and speak, to be up to my elbows in any arena —advocacy-wise, emotionally—I will step up to the plate.

Jersey moms have "logical impatience." They don't do things for you, but they know what you can accomplish, and they drive you to push to your potential. They also appreciate that sometimes your neighbor might need a little help too, there is a real community around them.

As a mom, I am most proud to have worked with California State University Northridge educators in the founding of two of very few schools in this country that allow kids of all learning abilities to go to school together every day. I am also involved in Wheels for Humanity, an organization that refurbishes wheel chairs and distributes them all over the world.

HOW ABOUT JERSEY GIRL STYLE? Fashion-wise, I grew up in Denville when hemlines were going crazy. Maxi skirts, skirts to-the-knee—I remember the first time you were allowed to wear PANTS to school! Of course, it had to be a pant SUIT, but I was all set because my mother made a bunch for me so I could wear pants all the time.

I find it interesting that people believe all Jersey Girls wear nail polish and have big hair. That wasn't MY Jersey Girl style or what I knew from growing up. Some of us would never wear nail polish, would never get done up. We had long, straight hair and were more concerned about trying to figure out how to be a good umpire than how to get dressed up! I just took my first makeup lesson this year. Crazy, right?

JULIE EDELMAN

"ACCIDENTAL HOUSEWIFE," AUTHOR · FORT LEE, NJ TURNPIKE EXIT 18W

Real Jersey Girls are all about finding the balance of "realness" that works for us as individuals. That's what led me to embrace my imperfections, come out of my broom closet, and admit I couldn't do it all. It led to my nickname and career as the *Accidental Housewife* author and journey to "spread the glove."

BEST JERSEY COCKTAIL HOUR? Ho-Ho-Kus Inn & Tavern.

THE ACCIDENTAL HOUSEWIFE'S JERSEY GIRL 'TINI? This cocktail (recipe at left) pays homage to the 1950s housewife who went about doing her chores with pearls and a smile, and ready with a cocktail for when her hubby arrived home from work. I always say that times have changed—and so have housewives! This "dirty" 'tini aptly reflects what a housewive's new attitude should be. A little dirt never hurt anyone.

Plus, if you drink one or more your home will automatically look a lot cleaner! So kick back and shake one—bottom's up, Jersey Girls!

BEST DINER AND FARE? Shrimp salad on a toasted bagel at the Plaza Diner.

FAVORITE JERSEY FOOD TO-GO: Foot-long dogs at Hiram's in Fort Lee, Kohr's frozen custard, and to-die-for doughnuts at Brown's restaurant.

FAVORITE JERSEY LANDMARK? Lucy the Elephant in Margate.

FAVORITE RESTAURANT? Cenzino's in Oakland—it's my "Cheers." Vinnie Padula is the owner and always in a "rare mood," which is what I love about him—that and his always-welcoming glass of Santa Margarita.

FORT LEE HANGOUT: Just off of Main Street there was a store called Broccoli where my friends and I used to hang out with the older cute guys who looked like they had just left Woodstock. I loved their clothes too—it was where I bought all my Landlubber jeans and cords.

SIGNATURE STYLE BACK IN THE DAY? Shoulder pads! I stuck them in everything—t-shirts, sweaters— only place I didn't wear them was to sleep. Everyone who knew me thought I'd had them surgically implanted!

JERSEY SUMMER JOB: Lifeguard at Fort Lee's Horizon House.

BEST JERSEY GIRL GETAWAY: When partying in the city, you could always skip out on a guy, or party, by saying you had to catch the PATH train home.

JERSEY GIRL 'TINI:

3 queen-sized pitted olives
Blue cheese for stuffing
2 oz. vodka or gin
Splash of dirt (i.e. olive juice from olive jar)
Mini-shaker and toothpicks
Chilled plastic martini glass (just in case you're truly accidental)

NOW:
1. Stuff olives with blue cheese and skewer on toothpick.
2. Combine vodka or gin and olive juice in a shaker.
3. Shake, strain, pour into chilled 'tini glass.

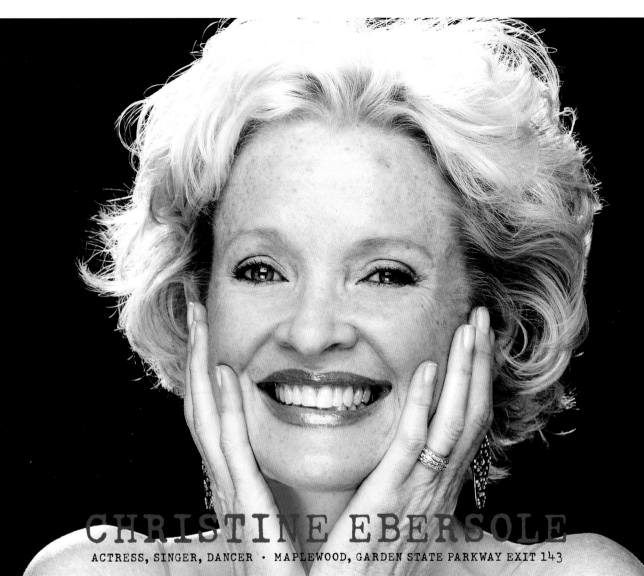

CHRISTINE EBERSOLE

ACTRESS, SINGER, DANCER • MAPLEWOOD, GARDEN STATE PARKWAY EXIT 143

The best thing about New Jersey is its diversity. In one day you could choose to hike the Appalachian Trail or take a ride down the slopes. You could explore the Pine Barons and search for the Jersey Devil. You could spend the day down the shore taking in the boardwalk of Seaside Heights or the Victorian splendor of Cape May. In the mood to try your luck, you could take your chance in Atlantic City or on one of our locally bred horse gems at Freehold Raceway or the Meadowlands. From diners to tomato pies, the food choices in New Jersey are vast, and many of the ingredients come from one of our 10,000 locally run family farms (we are the Garden State, after all). New Jersey's gems are endless. We have so much in a small state between the Metropolitan areas of New York City and Philadelphia, why would anyone want to live anywhere else?

JANELLE FISHMAN

MODEL, CLOTHING DESIGNER • SEWAREN, NJ TURNPIKE EXIT 11

GRADUATED FROM: Woodbridge High School.

MOST MEMORABLE NJ VACATION? Seaside Heights with six of my best friends and our moms! We rented a house and caused havoc on the boardwalk for three days!

FAVORITE NJ HANGOUT GROWING UP? The "Woods" in the winter and the beach in the summer. I can't disclose the locations because I wouldn't want to ruin it for the locals!

FAVORITE DINER? Used to be the Luna Bell Diner, an awesome, old-school place that looked like a castle and had old table-side juke boxes. Since Luna Bell closed, I go to the Reo Diner for my favorite pancakes.

FAVORITE BOARDWALK? Growing up it was Seaside Heights because it was the "party zone," but now that I am a mom I prefer Point Pleasant.

FAVORITE WAY TO CELEBRATE A HOLIDAY IN NJ? Hanukkah with my Aunt Shirley's family in her amazing William Hunt-designed house in Short Hills. She had pinball machines and an indoor golf range and loads of secret hiding spots perfect for hide-and-seek games for me and my fifteen cousins.

FAVORITE MALL? Woodbridge Center, my stomping grounds, of course.

FAVORITE HAIR PRODUCT? Lemon and water and sea salt mixed for spritzing in a spray bottle.

FAVORITE JERSEY BAND? Roadside Graves.

HOW WERE YOU "DISCOVERED"? I was discovered in Wildwood by a talent scout for Ford Models. I was twelve and visiting the shore with my Girl Scout troop. I had never considered modeling. I was the odd girl at school—too tall, small little face with huge eyes and lips. I was always teased by the boys.

WHEN DID YOU KNOW YOU WERE A BIG-TIME MODEL? I had three jobs back-to-back working for designer Vivienne Westwood, then for photographer Sheila Metzner, and then modeling in a Levi's campaign and a Cartier ad.

JERSEY GIRL WORDS? Even though I have had speech training for acting, and have traveled so much and have learned to speak different languages, when I am around friends and family or just excited, my Jersey Girl accent comes out to the fullest.

WHAT'S IN YOUR POK-A-BOOK? Lip gloss and superhero toys.

FAVORITE JERSEY GIRLS? My mom and my grandmother. In fact, I admire ALL of the women in my family. They all have accomplished such amazing feats, no matter their age. One grandmother survived the Holocaust, the other just stopped driving at the age of ninety-three. My mother has accomplished so much—as a travel agent, a teacher, an airplane pilot! And I am especially proud of my niece, who recently graduated college with honors.

DID YOU GO TO SUMMER CAMP? DANCING SCHOOL? I went to Girl Scout camp for five summers. I also took dance classes for eleven years at the Verne Fowler School. I studied tap, ballet, jazz, gymnastics, and musical comedy. I actually took class with the late great Brittany Murphy. I still see Verne all the time—she is one amazing lady.

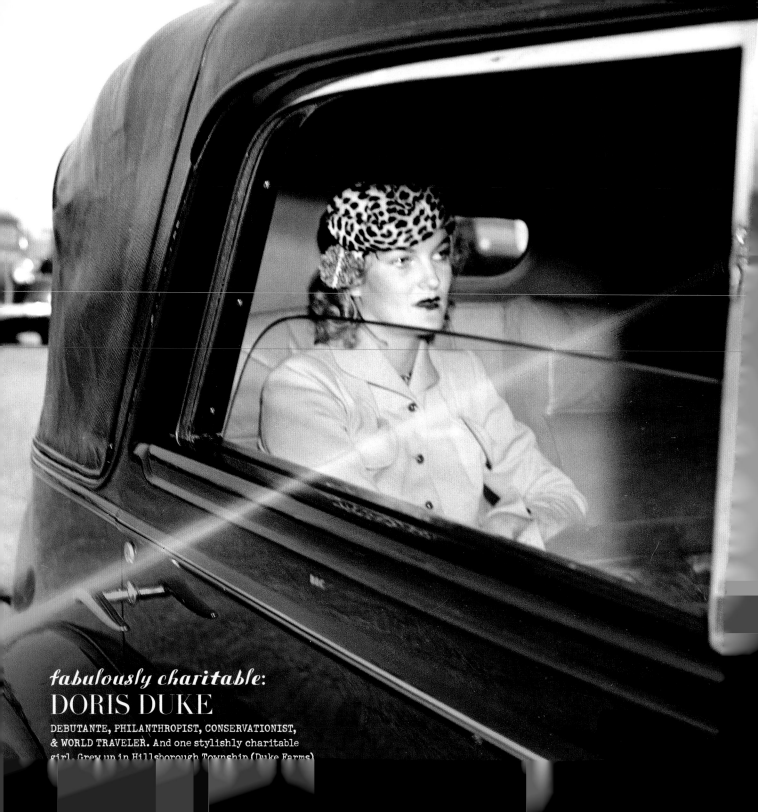

fabulously charitable:
DORIS DUKE

DEBUTANTE, PHILANTHROPIST, CONSERVATIONIST, & WORLD TRAVELER. And one stylishly charitable girl. Grew up in Hillsborough Township (Duke Farms)

STAR

JERSEY GIRL HALL OF FAME

broadway broad:
PHYLLIS NEWMAN

ACTRESS & SINGER. Born in Jersey City, 1933. Voted "Future Hollywood Star" by classmates at Lincoln High School. Starred on Broadway in shows including *On The Town, The Prisoner of Second Avenue,* and *The Madwoman of Central Park West.* 1962 Tony Award winner for *Subways Are For Sleeping.* Appeared on television shows including *What's My Line, To Tell the Truth,* and *Match Game,* and starred as Rene Buchanan on the soap opera *One Life to Live.* Founded the Phyllis Newman Women's Health Initiative, for which her humanitarianism was celebrated in 2009 with the first honorary Isabelle Stevenson Tony Award.

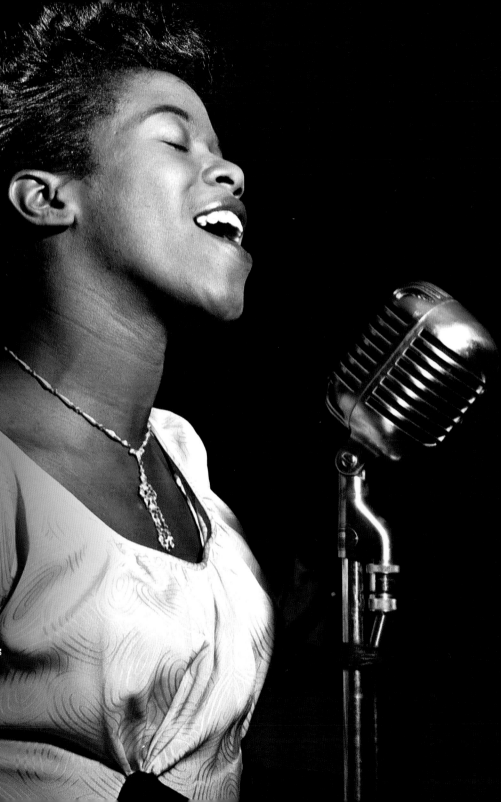

SARAH LOIS VAUGHAN

sassy songbird:

SINGER. Born in Newark, 1924. Attended East Side High School and transferred to Newark Arts High School (first U.S. arts magnet high school). Nicknamed "Sassy" and "Sailor" (for her sometimes salty speech). Sang "Body and Soul" and won the Apollo's amateur night in Harlem. Soon after she opened at the Apollo for Ella Fitzgerald. Hits include: "Misty," "Summertime," and "Send in the Clowns." Grammy Hall of Fame, George and Ira Gershwin Award for Lifetime Achievement, and American Jazz Hall of Fame award recipient.

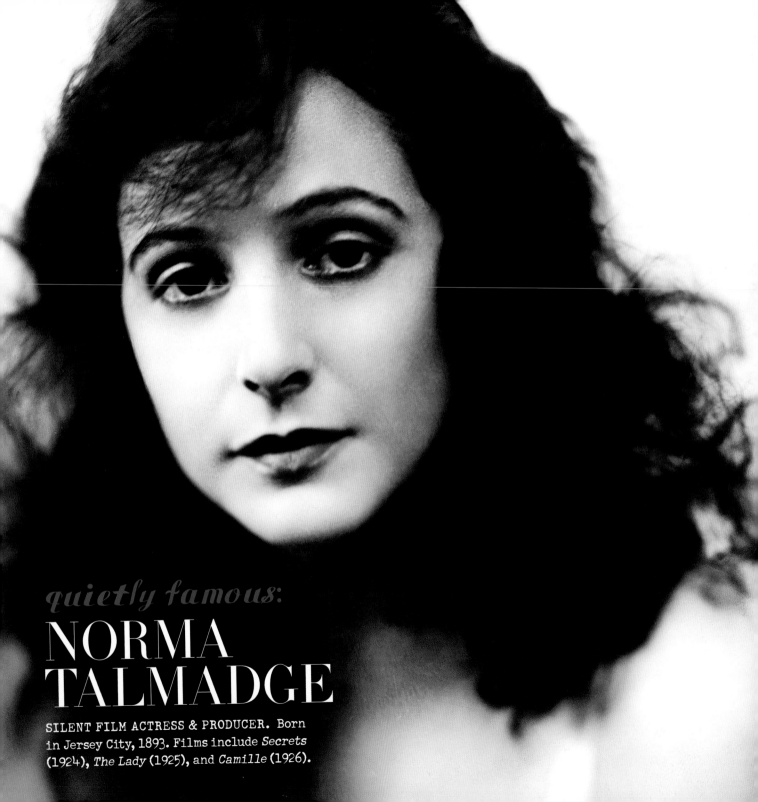

quietly famous:

NORMA TALMADGE

SILENT FILM ACTRESS & PRODUCER. Born
in Jersey City, 1893. Films include *Secrets*
(1924), *The Lady* (1925), and *Camille* (1926).

class act:
EVA MARIE SAINT

ACTRESS. Born in Newark, 1924. Academy Award Winner, Best Supporting Actress, *On the Waterfront* (1954). Drama Critics Award for her role in the Broadway production of *The Trip to Bountiful* (1953). Emmy Award winner for *People Like Us* (1990). Also appeared in films that include *North by Northwest, A Hatful of Rain,* and *Superman Returns.*

funny girl:
EDIE ADAMS

ACTRESS, SINGER, DANCER, & COMEDIENNE. Born Edith Elizabeth Enke (1927). Raised in Tenafly. Graduated Julliard School of Music and Columbia School of Drama. Appeared on *The Ernie Kovaks Show* and later married Kovaks. Starred on Broadway in *Wonderful Town* (1953), and won a Tony for Best Featured Actress for her portrayal of Daisy Mae in *Li'l Abner* (1956). Starred in films including *The Apartment* (1960) and *It's A Mad, Mad, Mad, Mad World* (1963).

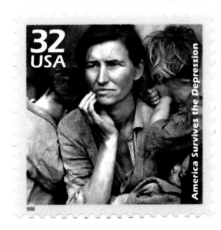

storied historian:
DOROTHEA LANGE

PHOTOGRAPHER & DOCUMENTARIAN. Born Dorothea Margaretta Nutzhorn in Hoboken, 1895. Documented the Great Depression and the aftermath of the attack on Pearl Harbor with photographs that would become iconic. Awarded the Guggenheim Fellowship for excellence in photography (1941)

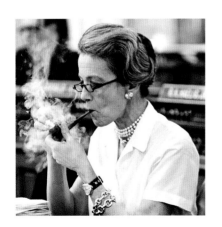

model citizen:
MILLICENT HAMMOND FENWICK

MODEL, ACTRESS, & POLITICIAN. Grew up in Bernardsville. *Harper's Bazaar* model, *Vogue* editor, author of *Vogue's Book of Etiquette.* New Jersey Congresswoman (1975 - 1983). First United States Ambassador to the United Nations Agencies for Food and Agriculture. Avid pipe smoker.

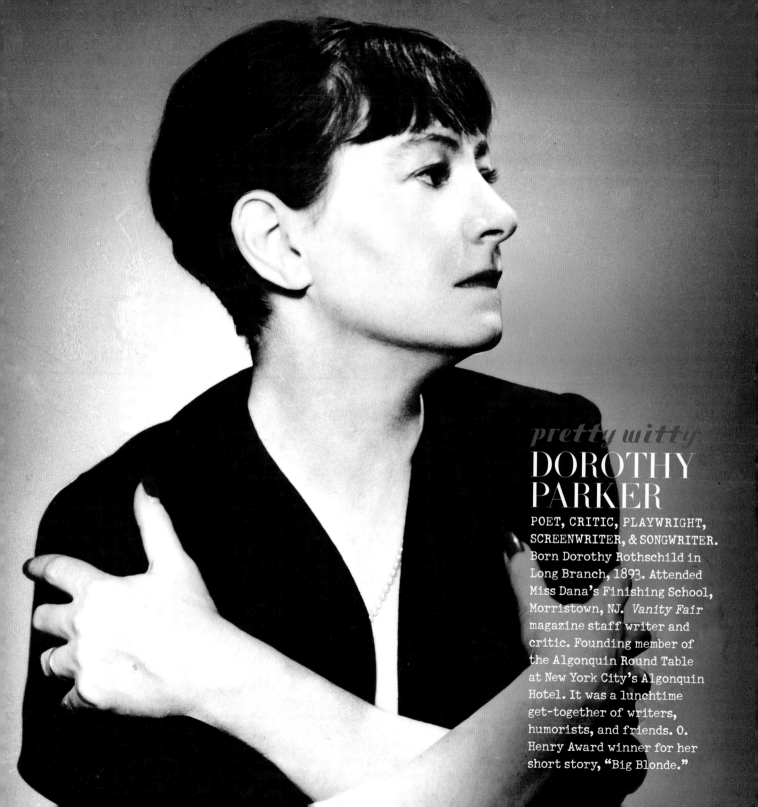

pretty witty

DOROTHY PARKER

POET, CRITIC, PLAYWRIGHT, SCREENWRITER, & SONGWRITER. Born Dorothy Rothschild in Long Branch, 1893. Attended Miss Dana's Finishing School, Morristown, NJ. *Vanity Fair* magazine staff writer and critic. Founding member of the Algonquin Round Table at New York City's Algonquin Hotel. It was a lunchtime get-together of writers, humorists, and friends. O. Henry Award winner for her short story, "Big Blonde."

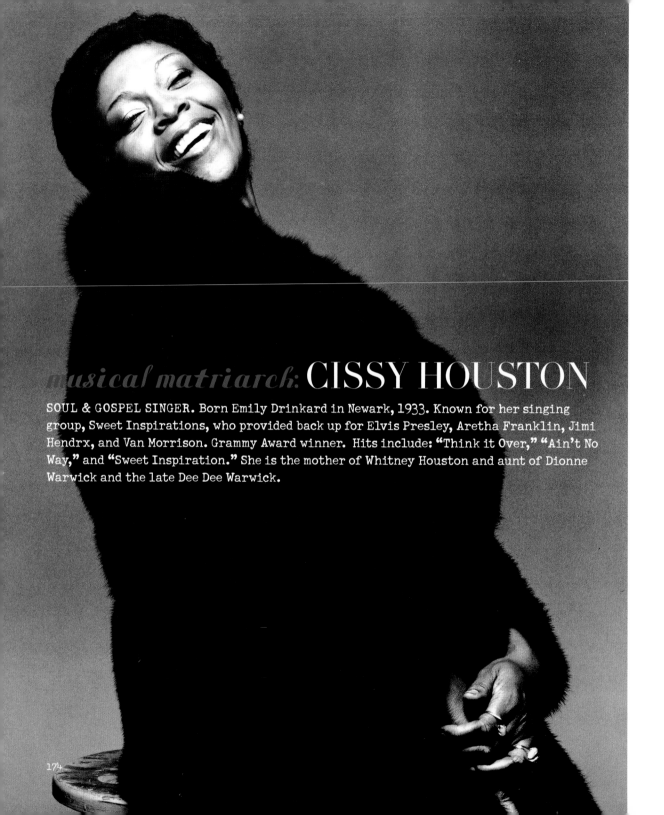

musical matriarch: # CISSY HOUSTON

SOUL & GOSPEL SINGER. Born Emily Drinkard in Newark, 1933. Known for her singing group, Sweet Inspirations, who provided back up for Elvis Presley, Aretha Franklin, Jimi Hendrx, and Van Morrison. Grammy Award winner. Hits include: "Think it Over," "Ain't No Way," and "Sweet Inspiration." She is the mother of Whitney Houston and aunt of Dionne Warwick and the late Dee Dee Warwick.

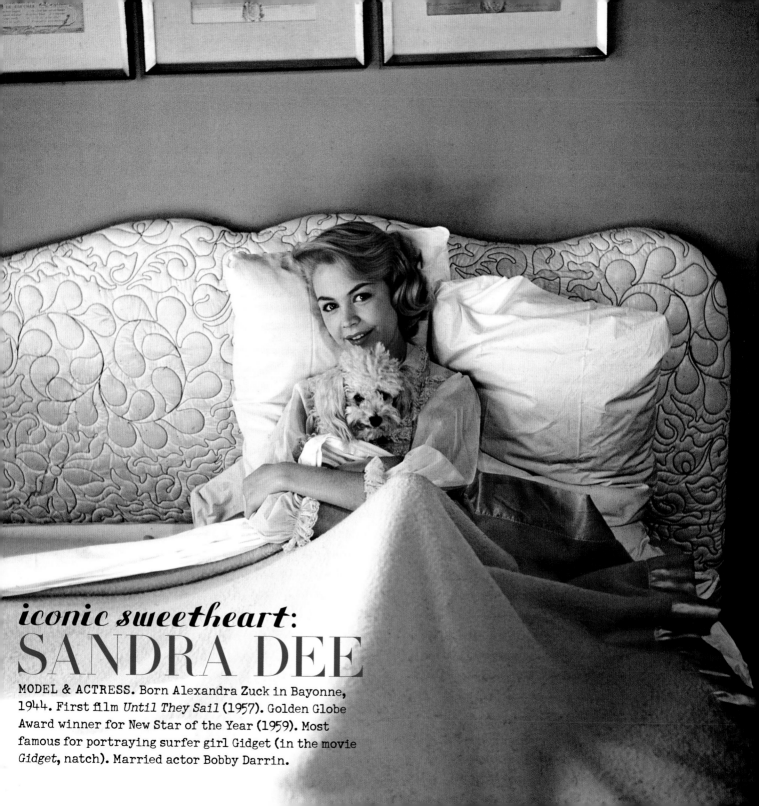

iconic sweetheart:
SANDRA DEE

MODEL & ACTRESS. Born Alexandra Zuck in Bayonne,
1944. First film *Until They Sail* (1957). Golden Globe
Award winner for New Star of the Year (1959). Most
famous for portraying surfer girl Gidget (in the movie
Gidget, natch). Married actor Bobby Darrin.

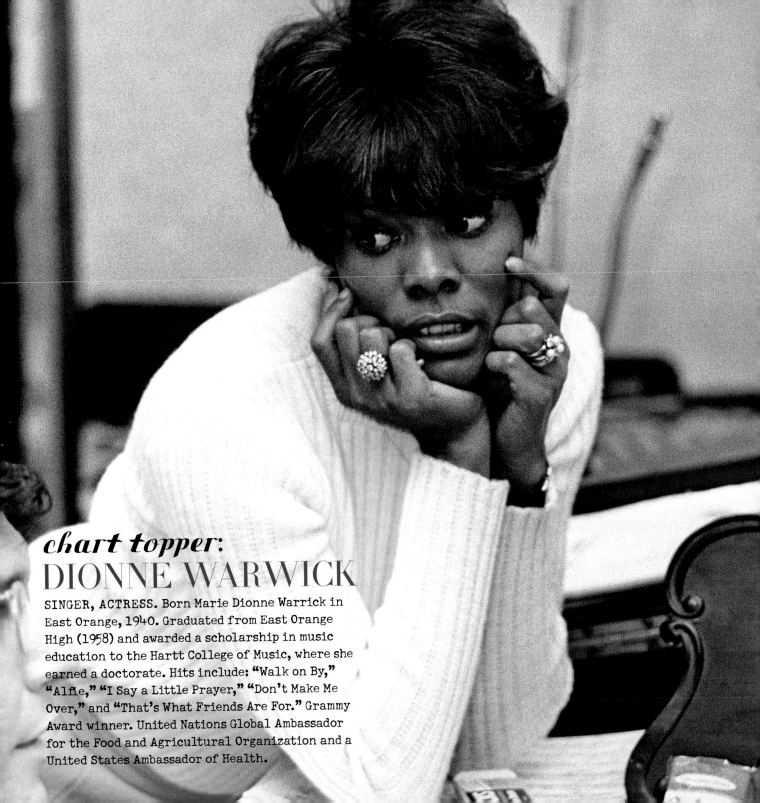

chart topper:
DIONNE WARWICK

SINGER, ACTRESS. Born Marie Dionne Warrick in
East Orange, 1940. Graduated from East Orange
High (1958) and awarded a scholarship in music
education to the Hartt College of Music, where she
earned a doctorate. Hits include: "Walk on By,"
"Alfie," "I Say a Little Prayer," "Don't Make Me
Over," and "That's What Friends Are For." Grammy
Award winner. United Nations Global Ambassador
for the Food and Agricultural Organization and a
United States Ambassador of Health.

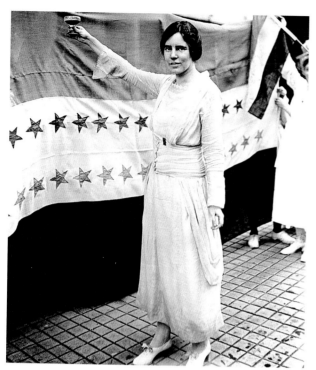

smart cookie:
ALICE PAUL

ACTIVIST. Paulsdale, NJ. Suffragist Leader, Secured Women's Voting Rights by campaigning for the passage of the Nineteenth Amendment to the Constitution.

first lady:
CHRISTINE TODD WHITMAN

LEADER. First female governor of New Jersey, 1994 – 2001. Appointed as Administrator of the United States Environmental Protection Agency (2001-03).

party gal: LESLEY GORE

SINGER, SONGWRITER, & ACTRESS. Born Lesley Sue Goldstein, 1946. Grew up in Tenafly. Was sixteen years old and a junior at the Dwight School for Girls in Engelwood when "It's My Party" became a #1 hit in 1963. Song went on to win Grammy Award for Best Rock 'n Roll Recording. Composed songs for the soundtrack for the1980 film *Fame* and received an Academy-Award nomination for the song "Out Here on My Own." Hits include: "You Don't Own Me" and "The Look of Love."

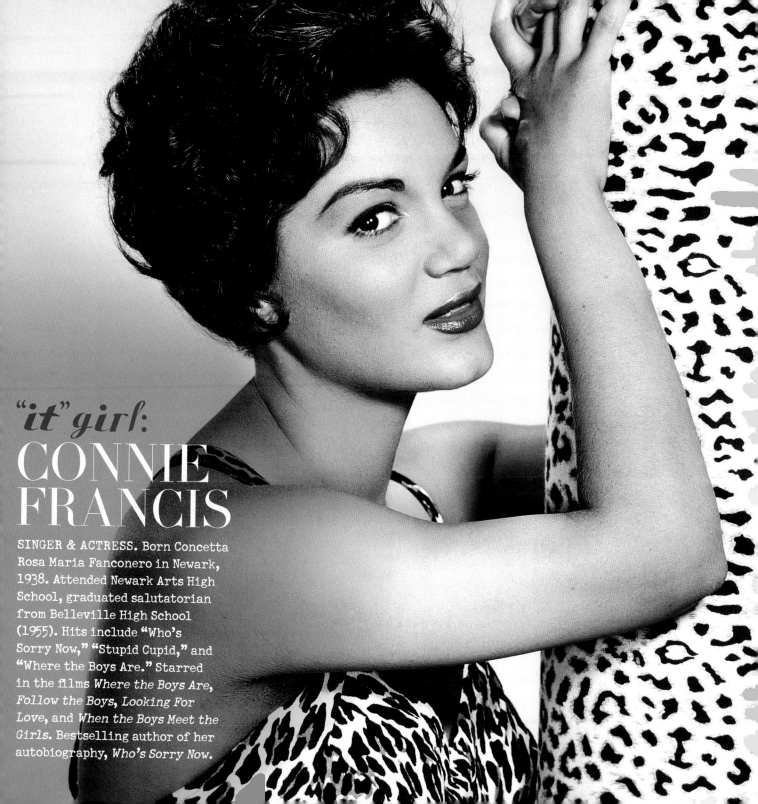

"it" girl:
CONNIE FRANCIS

SINGER & ACTRESS. Born Concetta Rosa Maria Fanconero in Newark, 1938. Attended Newark Arts High School, graduated salutatorian from Belleville High School (1955). Hits include "Who's Sorry Now," "Stupid Cupid," and "Where the Boys Are." Starred in the films *Where the Boys Are*, *Follow the Boys*, *Looking For Love*, and *When the Boys Meet the Girls*. Bestselling author of her autobiography, *Who's Sorry Now*.

HOME GIRLS

PASSAIC
Lisa Edelstein, Wayne
Vera Farmiga, Clifton
Debbie Harry, Hawthorne
Zoe Saldana, Passaic
Loretta Swit, Passaic

BERGEN
Edie Adams, Tenafly
Debby Boone, Hackensack
Katrina Bowden, Wyckoff
Julie Edelman, Fort Lee
Leslie Gore, Hackensack
Lea Michelle, Tenafly
Tara Reid, Fort Lee
Mira Sorvino, Tenafly
Timothy White, Fort Lee

MORRIS COUNTY
Laura Benanti, Kinnelon
Jancee Dunn, Chatham
Jane Krakowski, Parsippany
Fran Lebowitz, Morris
Laura San Giacomo, Denville

SUSSEX
Janeane Garofalo,
Newton

SOMMERSET
Doris Duke, Duke Farms
Millicent Hammond Fenwick, Bernardsville
Laura Parepon, Watchung
Keisha Spivey Epps, Somerset
Meryl Streep, Bernardsville

HUNTERDON
Christine Todd Whitman,
Hunterdon County

MERCER
Bebe Neuwirth, Princeton
PRINCETON GRADUATES:
Laurie Berkner
Ellie Kemper
Brooke Shields

BURLINGTON
Alice Paul, Mt.
Laurel Township

CAMDEN
Dena Blizzard, Waterford
Joanna Cassidy, Cherry Hill
Ali Larter, Haddonfield
Kelly Ripa, Camden

GLOUCESTER
Linda Fiorentino, Sewell
Patti Smith, Deptford
Betsy Ross, eloped in Gloucester

CUMBERLAND
Jonathan Adler, Bridgeton

ATLANTIC
Verne Fowler, Margate

UNION
Judy Blume, Elizabeth
Valerie Cruz, Elizabeth
Mary McCormack, Plainfield

HUDSON
Sandra Dee, Bayonne
Daisy Fuentes, Harrison
Dorothea Lange, Hoboken
Christina Milian, Jersey City
Phyllis Newman, Jersey City
Annette Rosario, Jersey City
Norma Talmadge, Jersey City

ESSEX
Bobbi Brown, Montclair
Tisha Campbell-Martin, Newark
Olympia Dukakis, Montclair
Christine Ebersole, Maplewood
Connie Francis, Newark
Chelsea Handler, Livingston
Anne Hathaway, Millburn
Lauryn Hill, South Orange
Cissy Houston, Newark
Whitney Houston, East Orange
Keishia Knight Pullman, Newark
Queen Latifah, Newark
Laura Plimpton, Nutley
Christina Ricci, Montclair
Eva Marie Saint, Newark
Elisabeth Shue, Maplewood
Martha Stewart, Nutley
Dionne Warwick, Newark
Sarah Vaughn, Newark
Rachel Zoe, Millburn
Christina Zorich, Montclair

MIDDLESEX
Colleen Fitzpatrick
(Vitamin C), Old Bridge
Janelle Fishman,
Woodbridge
Lisa Marie, Piscataway
Marie Moss, Colonia
Brittany Murphy, Edison
Susan Sarandon, Edison
RUTGERS GRADUATES:
Kristen Davis
Natalie Morales
Calista Flockhart

MONMOUTH
Barri Leiner, Middletown
Jodi Lyn O'Keefe, Cliffwood Beach
Gianna Palmienteri, Hazlet
Dorothy Parker, Long Branch
Natalie Schafer, Red Bank
Patti Scialfa, Deal
Ashley Tisdale, Deal
Wendy Williams, Asbury Park

OCEAN
Kirsten Dunst, Point Pleasant
Piper Perabo, Toms River

GIRLS ON FILM

jersey-fabulous films: a cool dozen

LITTLE BLACK BOOK Brittany Murphy calls upon her Edison roots to walk the walk in this bittersweet tale of a JG trying to make it as a television producer in the big city. (2004)

ATLANTIC CITY Louis Malle directs Jersey Girl Susan Sarandon as a sexy casino girl with costar Burt Lancaster as a low level mobster in this Oscar-nominated gaudy, gangster-filled boardwalk tale. (1980)

13 GOING ON 30 In "Freaky Friday" fashion, star Jennifer Garner flashes forward, fulfilling her wish to skip adolescence for a career as a fashion editor in Manhattan. Mark Ruffalo costars as her Jersey 'burbs BFF. (2004)

CHASING AMY Written and directed by Jersey Boy Kevin Smith, this indie romantic comedy stars Joey Lauren Adams as Amy (a Golden Globe nominated role) with costars Jason Lee, Ben Affleck, and Jason Mewes. Edgy dialogue a character all its own. (1997)

GARDEN STATE South Orange home boy Zach Braff wrote, directed, and starred in this quirky, brilliant, somewhat autobiographical film along with fab costars Natalie Portman and Peter Sarsgaard. (2004)

THE WRESTLER With Elizabeth as a backdrop, Mickey Rourke stars as faded pro wrestler, Randy the Ram (for which he received a Golden Globe and Academy Award nomination), with Evan Rachel Wood and the always-fabulous Marisa Tomei (she was Oscar nominated too!). (2008)

JERSEY GIRL Director Kevin Smith serves up a different side of his indie persona with this tug-at-your-heart film starring Ben Affleck as a single dad raising a Jersey Girl daughter on his own. Kevin's credits give a shout out to his daughter Harley Quinn as "the original Jersey Girl." Now that's cute. (2004)

JUST FRIENDS Ryan Reynolds and funny girl Anna Faris go from Hollywood to Hoboken (well, Canada PORTRAYING Hoboken) in this sweet story of unrequited love. Also stars Chris Klein and Amy Smart. (2005)

JERSEY GIRL Jami Gertz (Jersey Girl) meets Dylan McDermott (fancy guy by way of Queens) with shouts out to Hasbrouck Heights' Bendix Diner and Hackensack's Foschini's Bakery. Worth a watch just for the wardrobe, McDermott's good looks, and Aida Turturro's take on JG speak. (1992)

CHEAPER BY THE DOZEN The true tale of Montclair's own Gilbreth family (twelve children!), this quirky coming-of-age tale remains modern and moving on every level. (1950)

COYOTE UGLY Actress Piper Perabo calls upon her Toms River roots to portray a Jersey Girl from South Amboy trying to make it as a songwriter in Manhattan. John Goodman does everyone proud with his sweet take on being a Jersey dad. (2000)

GREETINGS FROM THE SHORE Like a Jersey Shore "Flamingo Kid", this film serves up authentic shore scenarios with mini golf, crabbing, and beach clubs, and stars the adorable Kim Shaw, Paul Sorvino, and a very handsome David Fumero. (2007)

KAREN DUFFY

ACTRESS, MODEL, TV PERSONALITY · PARK RIDGE, GARDEN STATE PARKWAY EXIT 168

HOMETOWN HOMEGIRL OR BFF? My best friend since seventh grade is Lori Campbell. Lori writes screenplays and I write comedy books. We work together, grew up together, vacation together, and now our kids hang out.

We met in Park Ridge in seventh grade. She is about eighteen months younger than me and her sister was in my grade and we met through her. When I went to college in Colorado, she followed, and now we live in the same building in New York City. I can literally tell her to look out her window while I stand on my balcony to get her opinion on an outfit!

We've had many great adventures and have been best friends for so long. I think there is something about coming from a similar background. I wouldn't have been on MTV if she didn't push me to try. That's just how we are.

TALES OF A JERSEY GIRL UPBRINGING? I grew up one of three sisters and with three girls getting ready in one bathroom, there was this constant sound of the hairspray...pssssssssst! They used to say "the higher the hair, the lower the class." I was more of a tomboy but BOY did my sisters have BIG HAIR, with many hours clocked getting it that way.

We three had nicknames. We were Duff, Buff, and Muff. They both did the first dance at their weddings to Bruce's version of "Jersey Girl."

DID YOU ALWAYS KNOW JERSEY GIRLS WERE A DIFFERENT BREED OF BROAD? Yes, when I went away to college (I went to Boulder and Cal Berkeley) I saw that people have such a distinctive idea of Jersey—without ever having been there! I am so PROUD to be a daughter of the Garden State.

It is a beautiful state. I just got back from Long Beach Island, where we always rent a house. My parents still live in the Rumson/Red Bank area, so I am still very connected to my roots.

FAVORITE MALL STORE? Funny enough, my father was the V.P. of the Rouse Company, a mall developer. James Rouse literally created the shopping mall. When my dad became V.P., he ran all the malls in NJ, Maryland, and NY.

In Paramus there are like six malls. The reason we moved to Bergen County was to open the Paramus Park Mall. So, I was the daughter of the manager of the mall. Doesn't get much better than that for a Jersey Girl, right?

I am not a big shopper. But I had every job at the mall. I did landscaping, was an elf at the holidays, worked maintenance, put the Christmas lights up, and took every light down. I worked there, so it wasn't my hangout.

I was the elf when kids would sit on Santa's lap and have their pictures taken. My sister was the Easter Bunny. I would take the pictures and say, "smile" and I could see her braces were shining and reflecting through the bunny costume! She was actually smiling and ruining all the pictures. I would say "not you!" and all of the mothers thought I was talking to their

kid. My other sister was Strawberry Shortcake. We are black Irish, and she was in this red wig— it was pretty funny.

Sometimes my friends, Aida Turturro and Elizabeth Bracco (from *The Sopranos*) and I will drive from New York to Paramus for what we call "competitive shopping." We hit Marshall's and TJ Maxx and all of the discount stores along Route 4. Along the way we buy a prize and whoever gets the best deal of the day gets the prize.

One time we were in the changing room in Loehman's and another shopper recognized my friends, who are well-known actresses. She asked us what we were doing there and Aida said "everybody loves a bargain!"

HOW WERE YOU "DISCOVERED"? I was in my late twenties and came to the party pretty late. I was walking into Bloomingdale's in Manhattan one day and someone asked me right off the sidewalk to be the "Esprit Girl." Another time I was with my friend Greg and a guy asked us to be in a jeans commercial. After that, I started modeling, but at barely 5'7"—and never having even done a sit-up—I was an uncomfortable, overfed New Jersey flower. But I kept getting cool gigs, like doing the Calvin Klein Jeans ads.

HOW DID YOU LAND ON MTV? I am part of a big, caring Catholic family and like a lot of Catholic families in my area, we knew the importance of working and volunteering. During the holidays foster children would live with us, and I had begun working at a nursing home in seventh grade.

I wanted to be a recreational therapist, to help people with profound disabilities. This type of therapy focuses more on what you can do and not what you can't do. Because I had been dealing with a geriatric population, many of them with hearing issues and Alzheimer's, I developed perfect diction and pronunciation, and knew how to speak loudly enough so they could

hear me, and so that I could keep their attention.

I had heard MTV was looking for VJs—so I took my experience of speaking loudly and clearly—and of holding someone's attention—and sent them a "cheese ball" two-minute video that I'd made. I sent the tape in on a Thursday, and the following Tuesday I went in for a screen test and got the job.

BEFORE THE JOB, WERE YOU INTO MUSIC? Never having had cable or videos in my apartment, I had only gotten to see them when I went home to visit my parents. MTV had been around for ten years but I wasn't jaded or anything; it was new to me. I identified more with the viewer than the artist. Some of the other VJs acted like they had written, directed, and starred in the videos. It was 1992, and music was having a grunge moment— interesting considering I was into Frank Sinatra and Barry White. I went to the museum of broadcasting to watch tapes of *The Frank Sinatra Show* and I noticed that he got dressed up for his show every single night. So I always wore a dress and heels, despite grunge being at its height in fashion.

FAVORITE ROCK STAR MOMENT? I remember being in LA over Christmas. I had to work on the twenty-third, so I didn't go home for the holidays. I stayed in LA and went to St. Victors in West Hollywood. And you know how you turn around and give the sign of peace to someone sitting behind you and shake their hand— "peace be with you"? Well, I look up and there was Bruce Springsteen. He took my hand and said "Merry Christmas, Duff." It was a true Christmas miracle.

FAVORITE PLACE TO HANG OUT WITH HIGH SCHOOL FRIENDS? I used to ski Great Gorge and Vernon Valley. I was on the track team and swim team and I liked being outdoors and in motion. Kayaking on the Navesink, or hanging out at Sandy Hook were also favorites.

JIMMIES OR SPRINKLES? Jimmies. Actually, half the family says one thing, half says the other.

FAVORITE DINER? WHAT'S YOUR ORDER? The Park

Ridge Diner has THE BEST cheesecake in the world.

We recently went back for a reunion. Pre-reunion we went to all of our places, like we were teenagers back in high school. We went to the Bagel Fair and to Lisa's Pizza, where they recognized me and we took pictures. We'd been going there for years. It was our place. The day Lori got her license we went straight to Lisa's and got a slice.

WHAT IS IT ABOUT JERSEY GIRLS THAT MAKE THEM SO RIPE FOR THE LIMELIGHT? I was just with Laura San Giacomo in Italy for a mutual friend's wedding. At this wedding we only talked to one another pretending we were Buddy from *Cake Boss*. Like "Hey, Laura, can you pass me the fondant?" Everything we did, we did as Buddy. We were decorating the bridal suite with roses and had the best time. We hadn't been friends until this wedding, so I said to her "How have I missed you all this time," and she said, "I don't know, I am a Jersey Girl," and I thought "Well, of course you are!".

ONE PIECE OR BIKINI? Not only a one piece—I have a swimming costume. Norma Kamali makes these amazing swim dresses, like my grandma wore. She always had this nice black skirted bathing suit when she took me to swim in the Navesink. When I found Norma Kamali I was like, "These are like Grandma's." They're modest and I am always moving so I liked to be covered up. They are awesome! Perfect for the Jersey Shore. My sisters are all tankini girls.

BRUCE OR BON JOVI? It used to just be Bruce—and then I had to interview J.B.J. a few times for red carpet and print. He is the most amazing guy. So now I am both.

I had to announce on MTV when his daughter was born and I announced that he and his wife just had a big fat baby girl. And they made me do it again! Ed Lover was like, "That's harsh." I didn't see anything wrong with it. What am I supposed to say, they had a skinny baby?! She was healthy!

BRITTANY MURPHY

ACTRESS · EDISON, NJ TURNPIKE EXIT 10

A JERSEY GIRLS TRIBUTE

VERNE FOWLER, VERNE FOWLER SCHOOL OF DANCE & THEATRE ARTS: Brittany was my student from age six until she left for California. I knew right from the start that she was something special, someone who would definitely have a career in show business.

Brittany had vocal training with my husband, Frank Kreisel, who was the musical and vocal director at my school. One year we did our musical theater show about World War II and she was so tiny that we had to have her stand on a box to reach the microphone to sing the Irving Berlin song, "Oh, How I Hate to Get Up in the Morning."

I will always remember the beautiful brown curls she had as a child—beautiful brown curls that she didn't like one bit! So many times I would sit with her mom, Sharon, in the dressing room trying to coax her out, but she made up her mind that she would not attend class with those curls!

We remained close friends, and I looked forward to seeing her every time she returned home for a visit.

MARIE MOSS: I was smitten with Brittany the minute we met. I was Fashion Director at *Seventeen* magazine and she had come by to meet the staff just prior to the release of *Clueless*.

She came into my office like a fiery ball of happiness! When I asked her what kind of clothes she liked, without hesitation she shared that she had gotten her jeans in the mall at Contempo Casuals, which (along with her accent) instantly convinced me that I was in the presence of a Jersey Girl! It wasn't until we were together a few years later on a photo shoot in Los Angeles that we discovered we had both attended Verne Fowler's school for musical theater classes. After all of these years, I have never forgotten Verne's husband Frank's song "It's the Performance That Counts," and I began singing the lyrics to Brittany between shots. She called her mom Sharon over to listen as we sang the entire song, together with Verne's choreographed motions still intact. Sharon got tears in her eyes at what must have been a surprise trip down Jersey's memory lane right there in the heart of Los Angeles.

Brittany was kind and vulnerable and charismatic. She was quirky and beautiful and soulful. I so admired her, and felt such a strong Jersey Girl connection to her that I felt tremendous pride in all of her amazing accomplishments, as if she somehow represented each and every one of us. Loved that girl, no doubt about it.

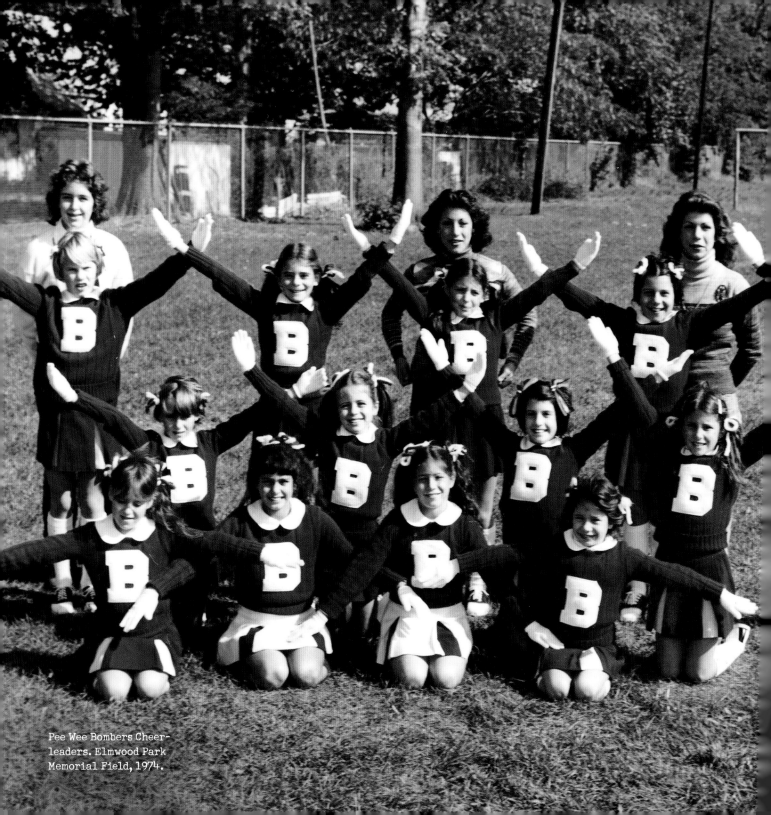

Pee Wee Bombers Cheer-
leaders. Elmwood Park
Memorial Field, 1974.

SOUVENIR

SWEET DREAMS ARE MADE OF THESE

MY NAME IS
JERSEY GIRL
WHAT'S YOURS?

PAPER MILL
Millburn, New Jersey

THE SOUND OF MUSIC

CAMP
CHICKAGAMI
1974.

On a hometown scale, Jersey Girls are conveniently just a car ride away from the very best in cultural cool. From cities like Newark that boasts the state's largest art museum and prestigious performing arts center (NJ PAC to the locals), to statewide homegrown theaters like Papermill Playhouse, Plays-in-the-Park, and McCarter Theater, the state is brimming with headliners and happenings, with culture to be celebrated at every exit.

Engaging, too, are the hands-in-the-air turns at so-much-fun-you-could-scream places like Six Flags Great Adventure and Bowcraft, as well as hands-in-the-air turns at cheering on the Jersey Devils, the Jersey Nets, or the JERSEY Giants (uh, well, they OUGHTA be!).

And Jersey Girls, one and all, never forget their first concert at the Meadowlands, their first parent-free Parkway drive down the shore, a trackside visit to Raceway Park, or a class trip to Trenton's New Jersey State Museum, Allaire State Park, or the Pine Barrens.

Many Jersey Girls share just as vivid, closer-to-home memories of "neighborhood culture" like decorating bikes and riding to the local VFW on the Fourth of July to sing songs of American and Jersey pride with local veterans, and of Girl Scout sashes covered in badges worn proudly down Main Street in town parades and at local malls for holiday performances. They share memories of bowling tournaments, of Saturday morning manicures with their moms, and of saving an allowance —and dad's loose change—for no-matter-the-season Sunday drives to play the games in seaside arcades.

Seems the most universally cherished Jersey Girl memory has to be a compassion for, and a connection to, friends and neighbors as though they were extended families in apartments and houses upstairs, next door, and down the street. This bond begins growing up at home, then grows to a lifelong, immediate feeling of kinship when discovering another Jerseyan somewhere out there in the world.

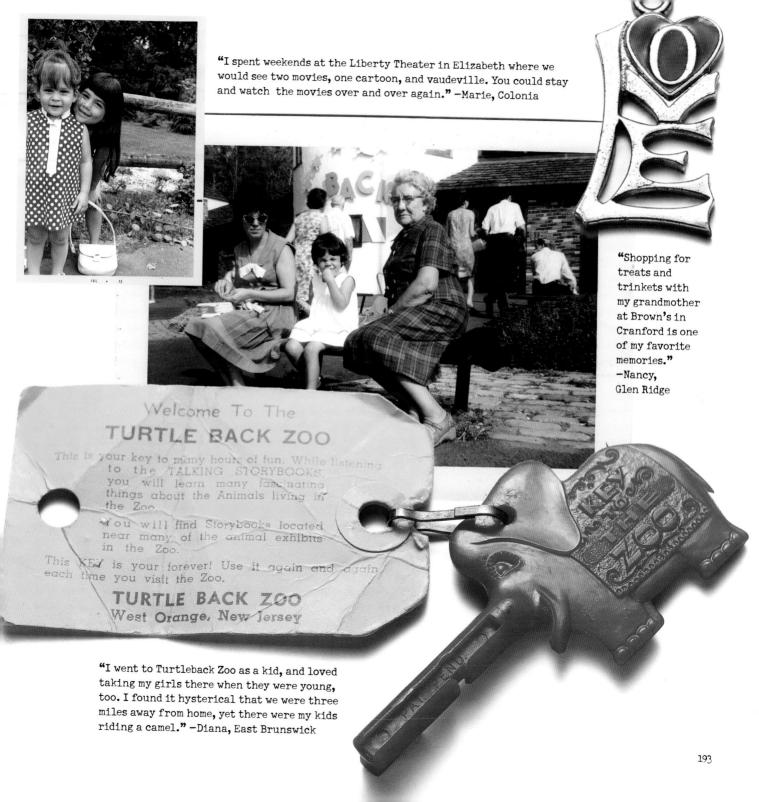

"I spent weekends at the Liberty Theater in Elizabeth where we would see two movies, one cartoon, and vaudeville. You could stay and watch the movies over and over again." —Marie, Colonia

"Shopping for treats and trinkets with my grandmother at Brown's in Cranford is one of my favorite memories."
—Nancy, Glen Ridge

Welcome To The
TURTLE BACK ZOO
This is your key to many hours of fun. While listening to the TALKING STORYBOOKS you will learn many fascinating things about the Animals living in the Zoo.

You will find Storybooks located near many of the animal exhibits in the Zoo.

This KEY is your forever! Use it again and again each time you visit the Zoo.

TURTLE BACK ZOO
West Orange, New Jersey

"I went to Turtleback Zoo as a kid, and loved taking my girls there when they were young, too. I found it hysterical that we were three miles away from home, yet there were my kids riding a camel." —Diana, East Brunswick

193

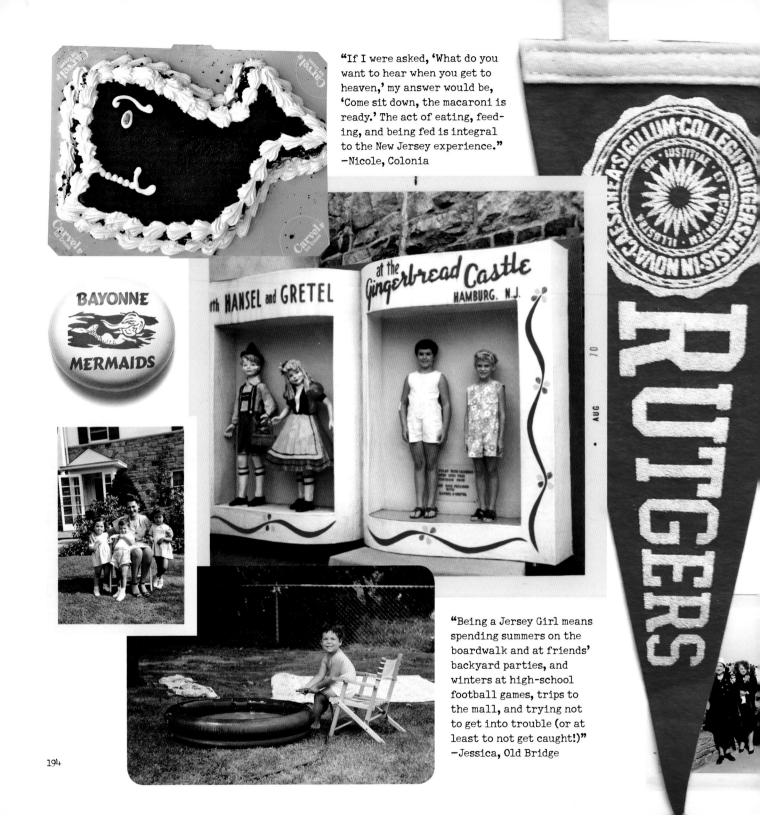

"If I were asked, 'What do you want to hear when you get to heaven,' my answer would be, 'Come sit down, the macaroni is ready.' The act of eating, feeding, and being fed is integral to the New Jersey experience."
—Nicole, Colonia

BAYONNE MERMAIDS

with HANSEL and GRETEL

at the Gingerbread Castle
HAMBURG, N.J.

RUTGERS

"Being a Jersey Girl means spending summers on the boardwalk and at friends' backyard parties, and winters at high-school football games, trips to the mall, and trying not to get into trouble (or at least to not get caught!)"
—Jessica, Old Bridge

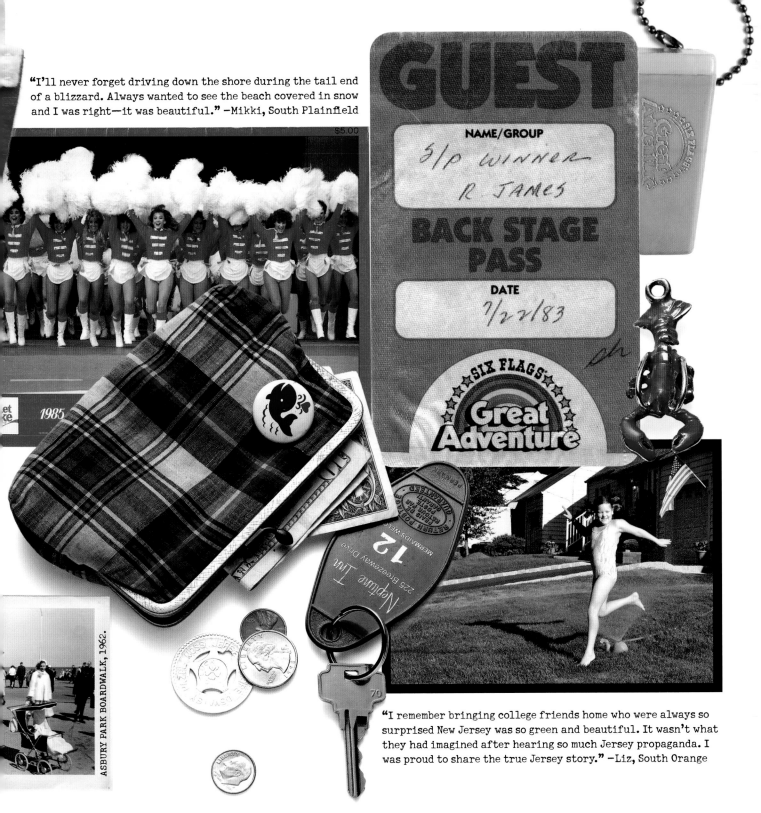

"I'll never forget driving down the shore during the tail end of a blizzard. Always wanted to see the beach covered in snow and I was right—it was beautiful." —Mikki, South Plainfield

$5.00

1985

ASBURY PARK BOARDWALK, 1962.

GUEST

NAME/GROUP
S/P Winner
R. James

BACK STAGE PASS

DATE
7/22/83

SIX FLAGS
Great Adventure

"I remember bringing college friends home who were always so surprised New Jersey was so green and beautiful. It wasn't what they had imagined after hearing so much Jersey propaganda. I was proud to share the true Jersey story." —Liz, South Orange

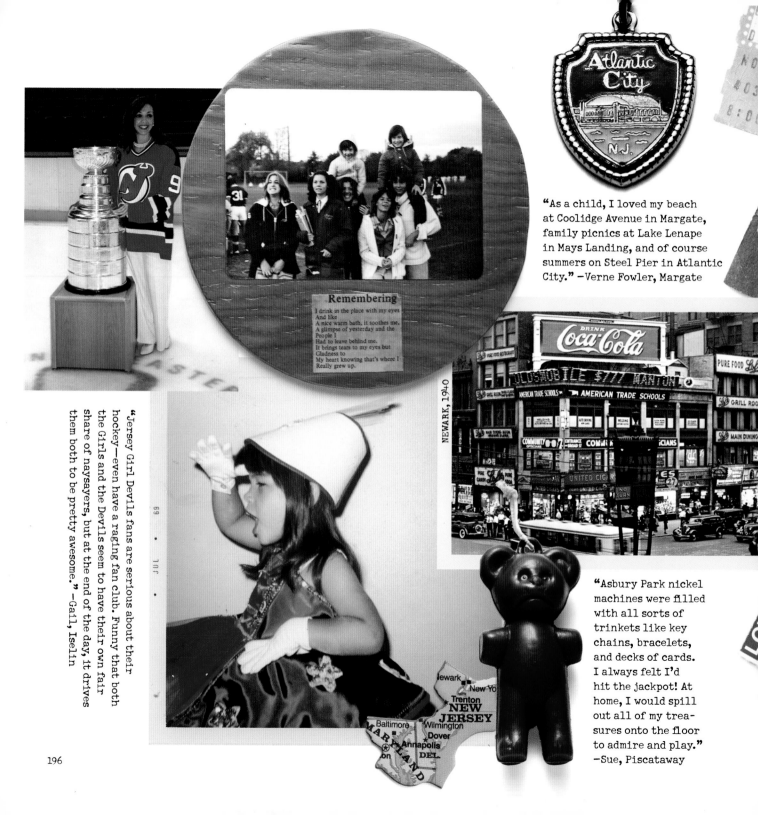

Remembering

I drink in the place with my eyes
And like
A nice warm bath, it soothes me,
A glimpse of yesterday and the
People I
Had to leave behind me.
It brings tears to my eyes but
Gladness to
My heart knowing that's where I
Really grew up.

"As a child, I loved my beach at Coolidge Avenue in Margate, family picnics at Lake Lenape in Mays Landing, and of course summers on Steel Pier in Atlantic City." —Verne Fowler, Margate

NEWARK, 1940

"Asbury Park nickel machines were filled with all sorts of trinkets like key chains, bracelets, and decks of cards. I always felt I'd hit the jackpot! At home, I would spill out all of my treasures onto the floor to admire and play." —Sue, Piscataway

"Jersey Girl Devils fans are serious about their hockey—even have a raging fan club. Funny that both the Girls and the Devils seem to have their own fair share of naysayers, but at the end of the day, it drives them both to be pretty awesome." —Gail, Iselin

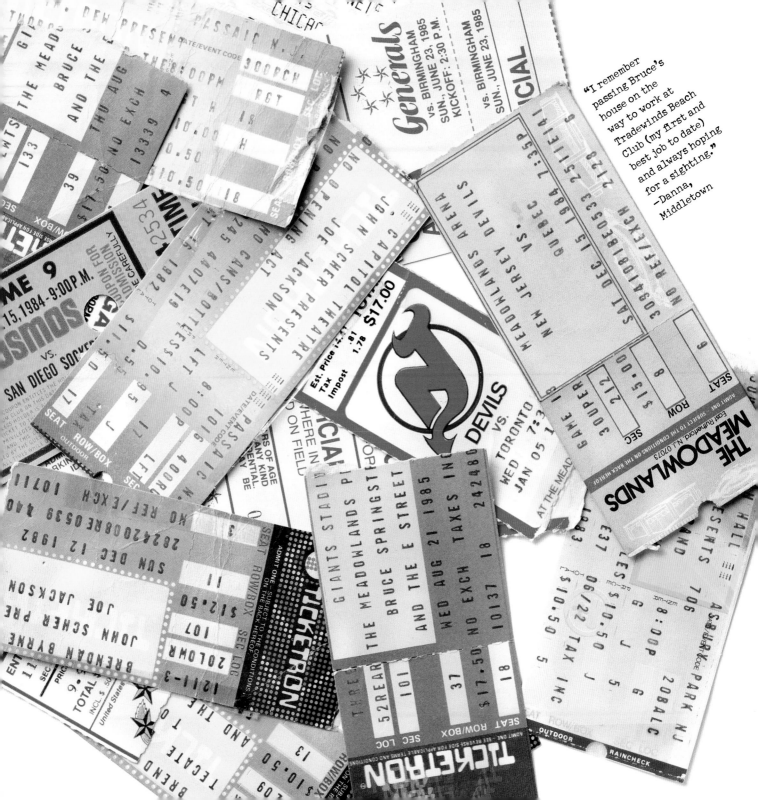

"I remember passing Bruce's house on the way to work at Tradewinds Beach Club (my first and best job to date) and always hoping for a sighting."
—Danna, Middletown

DEBBY BOONE

SINGER, SONGWRITER · HACKENSACK, GARDEN STATE PARKWAY EXIT 160

HOW DID YOUR FAMILY LAND IN THE GARDEN STATE?
My parents were married quite young and were living in Texas while my father attended North Texas State. He moved to New York to do *The Arthur Godfrey Show* and attend Columbia. And with friends already based in New Jersey who commuted into the city, they decided to settle there (my mom famously told my dad she "didn't want her family to live in a concrete jungle" when the idea of living in Manhattan was raised). They bought their first home in Leonia.

I love saying I'm from Hackensack, it's such fun because people don't expect it. And Frank Sinatra is from New Jersey so for me it has always been very cool to be from New Jersey.

When I was born my parents bought a house in Teaneck. It was a Tudor. My mom told me one of the reasons they loved the house so much was because it was in a big Catholic neighborhood full of kids—one of our neighbors had fifteen kids! Our pediatrician lived next door and worked out of his home. I only lived in New Jersey for four years, but it was idyllic.

The doctor that delivered most of the neighborhood kids was Dr. Leonard Brown—my mom adored him! He sent regards when my record came out, and said he was proud to have been the one who brought me into the world!

HAVE YOU BEEN BACK TO VISIT? I have four kids of my own, and oddly enough one of my twins went to Princeton. I visited her there many times each year and proudly watched her graduate. I can't imagine having a more beautiful place to attend college. She didn't even do a year abroad like the other students; she just stayed on campus. She married a Jersey Boy and his parents still have a house at the Jersey Shore. I think she considers herself part Jersey Girl.

Career-wise, I played the Garden State Arts Center with my dad when we were first working together and I have played there at least a few times on my own. I did an afternoon show there with my current act, which is a tribute to my mother-in-law, Rosemary Clooney. I love the Great American Songbook tunes and classic standards.

I also worked with Frank Sinatra in Atlantic City at Resorts International.

THAT HAS GOT TO BE THE ULTIMATE JERSEY GIRL STORY! It was pretty insane, to be asked to do the show, to open for Frank Sinatra for a few weeks! Just to have the opportunity to stand in the wings and listen to him was incredible. He later invited me to do benefits for his charities and to stay on the compound in Palm Springs. He was so lovely to me, incredibly nice, generous, and supportive.

We invited him to our wedding and he couldn't attend but sent me ten place settings of my china. Who does that? Frank Sinatra does! Then we sent a birth announcement when my son was born and he sent a sterling baby cup that was engraved "Welcome To This World." He was a class act all the way.

GOT A FAVORITE SINATRA TUNE? I think like many people I am crazy for "In the Wee Small Hours of the Morning." I do a melody of that song and "It Never Entered My Mind" in my show.

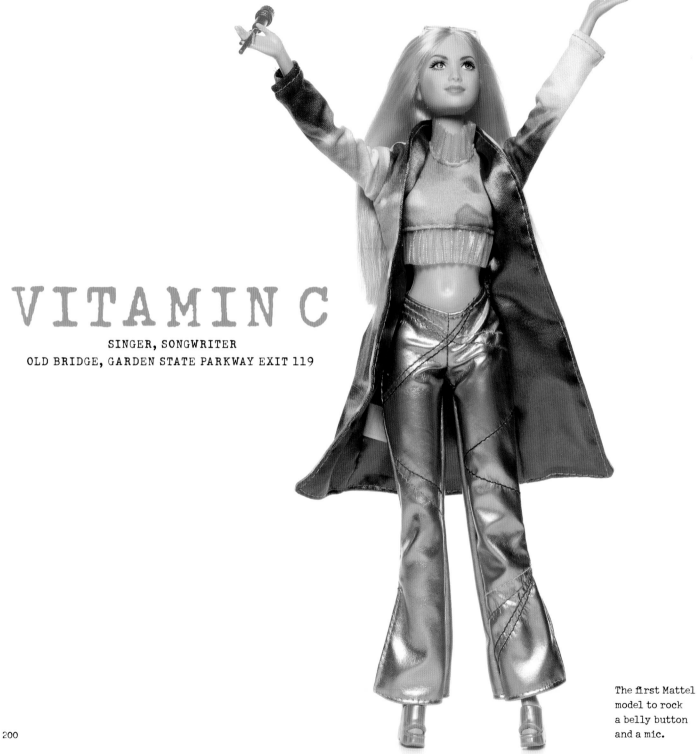

VITAMIN C

SINGER, SONGWRITER
OLD BRIDGE, GARDEN STATE PARKWAY EXIT 119

The first Mattel
model to rock
a belly button
and a mic.

REAL NAME? Colleen Fitzpatrick.

HIGH SCHOOL? Cedar Ridge (now Old Bridge High School).

HOW WERE YOU "DISCOVERED"? I was in school plays. I was the lead in *Sweet Charity* my senior year and was in high school bands.

I was trained in dance from the time I was two. I started at Miss Roxanne's in Old Bridge and once I was old enough I trained with Verne Fowler. It was a wonderful, competitive program. I went there for years and it was an incredible part of my childhood. That training gave me the basis for everything I have done.

I participated in the Plays-in-the-Park program in the late '70s and it was amazing. They do really high level productions. When I was nine I was Baby June in *Gypsy* and an agent in the audience thought I had potential. That was the start of my getting a manager and going on auditions. Marianne Leone, who managed Robin Givens, Kirsten Dunst, and Matt LaBlanc signed me on.

I remember being called for an audition for the movie *Hairspray* and the casting people thought I was too "plain," so the next day I went back right from the beauty parlor with makeup and a beehive and I got the part of Amber Von Tussle. Debbie Harry and Sonny Bono were cast as my parents. That's where I got to work with Jersey Girl Debbie Harry.

The band scene in Cedar Ridge was all Jersey "hair band" because of Bon Jovi's popularity, and proximity to my town. I jammed with some people. The kids were more into '60s Brit Pop and the Byrds, but everyone at the time just wanted to be in Bon Jovi, and none of the hair band wanna-bes wanted a girl in the band.

All of the posters around school and town read, "Looking for a lead singer—must have hair and attitude." I answered an ad in the *Village Voice* and joined a top grunge band at the time called Eve's Plum.

They wanted to do rhythmic stuff, but we played what we knew and what was popular at the time. I was introduced to a whole different kind of music.

The band broke up and I wanted to do something that borrowed from all of my interests. I wanted to do character-driven, post-modern stuff and include my dance background. That is when I became Vitamin C. It was meant to be a lot quirkier, but I became part of a youth quake of young artists at the time. I rode the wave without being a part of that age group. Vitamin C had hair and attitude, but of a different ilk!

DID YOU GO TO THE PROM? MEMORABLE DRESS? I didn't go to my own prom, but I went to the senior prom with a Junior. Oh, yes, the dress! It was a white over-the-top '80s fluffy extravaganza that I got at the Woodbridge Mall, and I wore my hair up. My mother called it a "Gibson Girl" 'do and I had no idea what she was talking about, but it was popular in the 1890s.

I bought something I kind of liked and that my boyfriend liked because I was just beginning to be a little "left of center" and he begged me not to wear anything wacky—to look "normal."

FAVORITE MALL STORE? Fashion Bug.

VITAMIN C BARBIE, LIPSTICK, AND VIDEO GAME?! Yes, Mattel made a Vitamin C doll, Tommy Hilfiger made a lipstick, and E.A. Sports designed a video game. I was the first Barbie doll to have a belly button! It was all crazy, weird, and exciting.

FAVORITE BEACH OR BOARDWALK? We would go to Manasquan after school beginning in May and my parents took my family to Belmar. I loved Kohr's frozen custard.

FAVORITE DINERS? The best diner was El Matador, which is now the Galaxy. We used to go to the Amboy Cinema and then to El Matador. At some point the Millbrook Diner in Mataway (now Park Place) became a favorite hangout. To this day my mom talks about the Woodbridge Diner.

Olympia reading to her daughter, Christina, and son, Peter.

OLYMPIA DUKAKIS & CHRISTINA ZORICH

ACTRESSES · MONTCLAIR, GARDEN STATE PARKWAY EXIT 153B

CHRISTINA: I was born in Manhattan, and grew up on the Upper West Side. My parents were working actors and had started the Whole Theater Company. It was a group of directors, actors, and students who had studied at NYU, at the Tisch school, with my mother, Olympia.

Some of the people my parents were working with lived in Montclair. They shared stories of the amazing New Jersey public schools, specifically of those in Montclair. All of the actors from the company began moving there too. It was a collective decision, and that is how we all landed there. The Company became an extended family to me.

I felt like the whole town was a park. The doors were always open, kids played outside. There was an openness in NJ. It felt idyllic, very Americana. Sometimes the sense of speed and attitude in New York, with such high technical standards, results in a loss of humanity. This is what was captured by the Whole Theater Company. They took risks. To me it was very deep and profound to deliver a performance and feel like you could be touching a community.

I started to take classes in New York. There was such a competitive high standard and a demand for a certain level of achievement. I found there was more "air" around the process in NJ to develop organically.

All three of the kids in my family felt a real sense of purpose in Montclair. And as determined as we were not to be "in the business" (we all are now in some way), we grew up with a sense of giving back to the community and responsibility to contribute.

Where you perform affects your choices and your voice as an artist—it affects what needs to be heard and said and that was very true for the Whole Theater. That's what was special about my experience, not just that hometown all-American feeling, but also the feel of an artistic community that was exciting and connected to the area. There was a deeper sense of responsibility to the people around you. I am very grateful to my parents and the company of actors for that.

It's ingrained in my brain—even if I ran from it as a teenager for a moment. I have such a sense of responsibility to contribute. Even if I am not acting—that feeling of responsibility is always part of me. And I miss it now.

OLYMPIA: We were living in an apartment and had a third child on the way and I wanted some collateral. If we stayed in New York, we would have needed a doorman, and that would have taken more money. We wanted more space and good schools for our children. We had friends in Montclair, so I thought why not BUY a house? We went out to New Jersey and bought the second home we looked at. It was like a dream house, with a long, winding driveway. The rest of the theater company we had in New York came out to New Jersey along with us.

Our first production in Montclair was *Our Town*, to commemorate our arrival there. We revisited classics, new plays, and American plays that we thought were relevant. European works too.

There is a wonderful ethnic mix in the state—Portuguese, Italians, Asians, Jews—and, of course, there is a big Greek population! There is something wonderful about the fact that they are all there, mixing and making the towns what they are. And New York is just next door, so you can come and go. You are always right there in the thick of it. And the beach is around the corner.

We still visit dear friends, Rosemary and Al Iverson, every Christmas in New Jersey. She was the president of the board of the theater company. I have tremendous love and respect for her. I have a son who still lives in Montclair. His daughters are my favorite Jersey Girls!

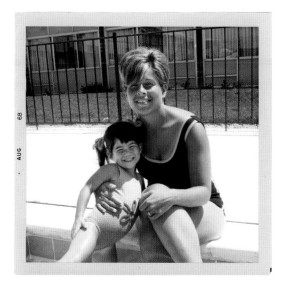

Barri and mom, Ellen.

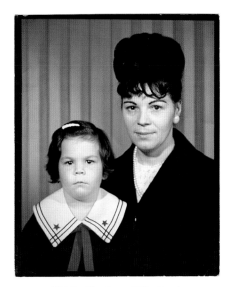

Little Marie and Big Marie.

From the bottom of our Jersey Girl hearts we'd like to thank: Andy Barzvi and Lyle Morgan at ICM. Cindy De La Hoz, Bill Jones, and the gang at Running Press. Tereasa Surratt, Elizabeth Warner, Jancee Dunn, Judy Blume, Aimee Herring, Mike Caffrey, Michael Coakes, Timothy White, Michael Buess, and Charles Farrell. To all the fine Jersey Girls (and a few Jersey Boys) who were eager to share their lives, loves, memories, souvenirs—and tattoos. A BIG thanks to our crazy talented designer and honorary Jersey Girl, Nancy Kruger Cohen. Love and thanks to our fierce and fabulous families and friends. x, MARIE & BARRI

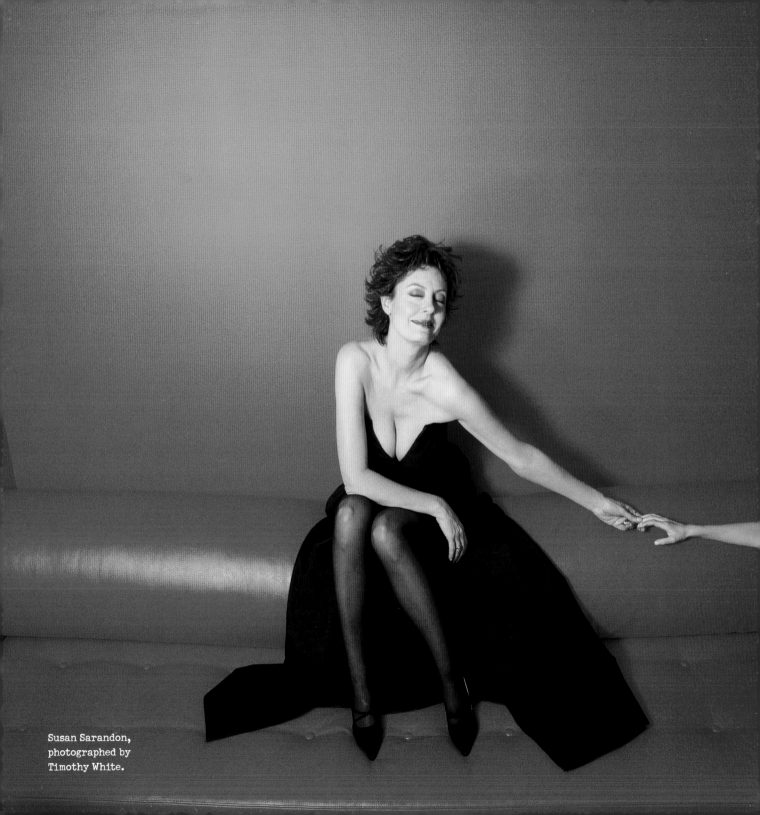

Susan Sarandon,
photographed by
Timothy White.

END NOTE

TAWKING WITH JERSEY BOY AND CELEBRITY PHOTOGRAPHER TIMOTHY WHITE

TELL US ABOUT THE COLLECTION OF PHOTOGRAPHS THAT YOU DONATED TO THE NEW JERSEY HALL OF FAME? It is a collection of photographs of famous Jerseyans, everyone from Calista Flockhart and Elizabeth Shue to Jack Nicholson and Anne Hathaway. The first stop for this exhibit is the Posh Den Gallery in Asbury Park, and it will go on to travel the country. I am proud to be a Jersey Boy, and when I realized I had photographed so many famous Jerseyans, the idea for a gallery show was born.

The idea came to me when I was invited to attend the New Jersey Hall of Fame induction ceremony. I was so impressed that so many amazing performers attended. I mean, not just showing up and walking out, these people stayed for HOURS. I mean, how do you get Jack Nicholson to come and stay for dinner—he is Hollywood royalty!

The event was so inspiring. Danny DeVito sang with Bruce Springsteen, Jack Nicholson had Joe Pesci and Yogi Berra induct him. I was inspired and totally "got" why these people hung out. There is a Jersey "thing." There is something about being from New Jersey. There is a pride. There is something "there," that unless you are from Jersey, you can't get it. And even though it is freakin' Jack Nicholson and Springsteen, they got it too. They felt it too. We are all like alumni—Jersey alumni.

WHAT EXACTLY IS THIS "JERSEY THING"? I remember meeting Joe Pantiliano ("Joey Pants") for the first time. We were talking, doing the Jersey thing, you know, feeling a familiarity. It went like this:

TIMOTHY: "Where'd you grow up?"

JOE: "Fairfield, Cliffside Park."

TIMOTHY: "I grew up in Fort Lee. My cousins in Fairfield went to Cliffside Park High. Do you know my cousin, Joanne Cappola?"

JOE: "Yeah, I know Joanne Capolla"

The next thing I know we have Joanne on the phone.

JOE: "Hey, Joanne, it's me, Joey Pants. I'm rich and famous now."

I don't know what it is, if it is being in the shadow of New York City, but there is an "in-your-face" challenge that becomes a part of your personality. There is always something about going over the river and then coming back home. Bruce writes about it all the time, driving on the turnpike into the city and coming back home. It is a hard thing to put into words, but it is a sense of pride, a real strength, a part of our personalities—something in the water.

WHAT ABOUT THE GIRLS? Whether you turn out to be Meryl Streep, Governor Whitman, or the gum-snapping chick on the boardwalk—they are all versions of the "it" of a Jersey Girl. My sister is a very dignified mom who works at the Newark Museum, but she's still a Jersey Girl. I sat on her shoulders at the Steel Pier in 1965 and know that she is the same Jersey Girl at sixty that she was back then. It is the Jersey Girl "it" factor.

I've been photographing Harrison Ford for almost thirty years and we are good friends, and I met Calista once at a shoot. I first realized she was a Jersey Girl when we were all out together, which, of course, led to a "which exit" turn in the conversation. I was happy for my friend—that he was with a Jersey Girl.

That's what it is about Jersey. I felt the same way about working with Queen Latifah on a shoot for her fragrance. That is one girl who is so proud of her Jersey roots. Her dad came to the shoot and I talked with him between shots. There's just a real connection, without saying a word it sort of levels the playing field—a shared pride of where we are all from. Certain places in the world are really about roots, and Jersey is one of those places.

MEMORABLE JERSEY SHOOTS? In 1988 I shot the Bon Jovi *New Jersey* album cover for *Rolling Stone*. I went down to Seaside Heights and met the owner of the pier and convinced him to let me shoot the band there. The guys came down for the shoot and somehow word got out that we were doing this. It was even announced on the radio and a thousand kids showed up. It was crazy. I met my wife that night because she was a makeup artist working with Jon. We just celebrated twenty years, and Jon and I are still friends.

I shot Guns N' Roses for their very first *Rolling Stone* cover. The guys were getting into trouble, and they happened to be in New Jersey, so their manager asked that I not bring them into Manhattan for the shoot because he was afraid they'd never make it back for the concert the next day. So I'm thinking, "OK, I have to shoot a *Rolling Stone* cover in New Jersey, what am I going to do?" They were staying at a hotel out near the Meadowlands so I set up a studio in the conference room of the hotel and we did the shoot right there.

Afterwards, I called my friend who owned a biker bar called "Mrs. J's" next to the Stone Pony and asked if I could bring these guys down there to do a shoot. They were just breaking, but he knew who they were and told me to bring them down. Their van showed up and they were crazy. Guns N' Roses in Mrs. J's biker bar—just surreal. The guys had tattoos, but it turns out they were "Sunset Strip" tattoos, perfect tattoos, and the guys at Mrs. J.'s were "Jersey"—veteran bikers with homemade tattoos—a whole 'nother ballgame. I come walking in at 3AM with these slick guys in their costumes and, well, it got nasty. While I was shooting it was crazy loud. I stood on the pool table in my little '80s outfit with my long hair thinking to myself, "Who the hell am I, this skinny guy, to think I can organize these bikers and lunatics?" In the end, we got a great image, but the guys were a little late getting back.

GROWING UP "JERSEY" MEMORIES? Spending prom night over night, 'til sunrise, underneath Asbury Park Convention Hall. Hanging out at the Fort Lee and the Plaza diners.

FAVORITE JERSEY GIRL OUTSIDE OF FAMILY? Susan Sarandon is a close friend of mine. I have photographed her more than anybody. Talk about a down to earth woman. She walks her kids to school and every time I photograph her one of her kids is with her. We share a respect for our Jersey roots, a pride in where we come from.

ONE WORD TO DESCRIBE SOME OF THE GREAT JERSEY GIRLS YOU'VE PHOTOGRAPHED: Susan Saradon: FAMILY. Calista Flockhart: SMART. Anne Hathaway: ELEGANT. Queen Latifah: POWERFUL. Bebe Neuwirth: SEXY. Brittany Murphy: ENERGY.

PHOTOGRAPHY CREDITS